MW00818096

IN BLACK AND WHITE

Prints from Africa and the Diaspora

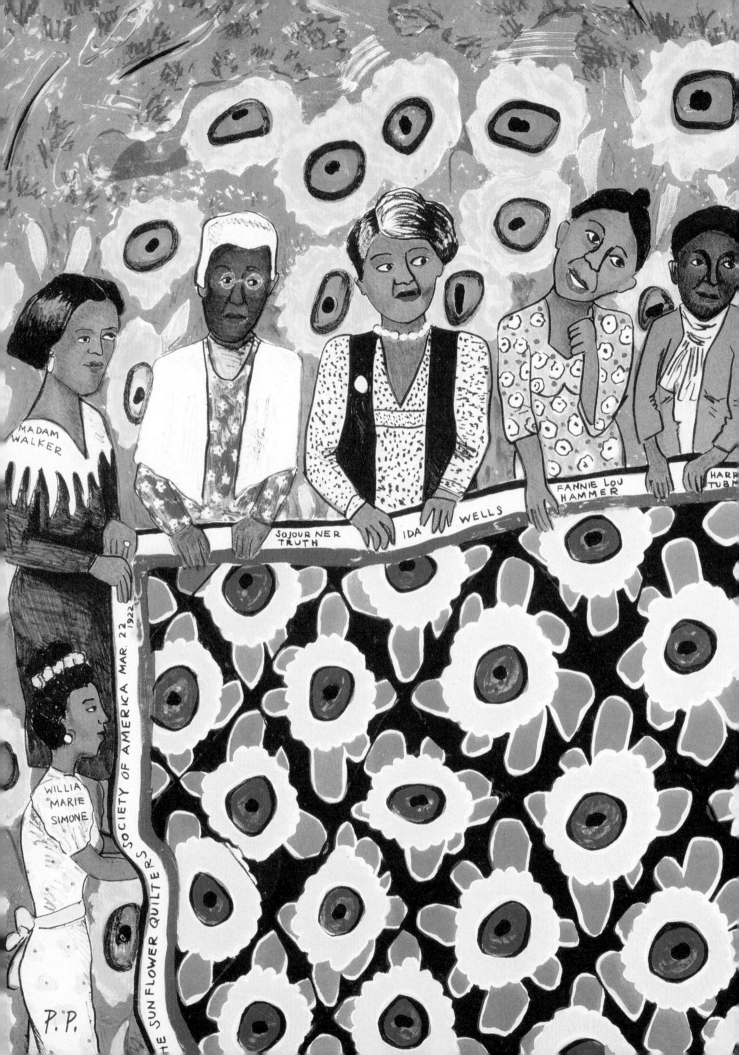

IN BLACK AND WHITE

Prints from Africa and the Diaspora

Gill Saunders and Zoe Whitley

V&A Publishing

First published by V&A Publishing, 2013
Victoria and Albert Museum
South Kensington
London sw7 2rl
www.vandapublishing.com

Distributed in North America by
Harry N. Abrams Inc., New York
© The Board of Trustees of the
Victoria and Albert Museum, 2013

Paperback edition
ISBN 9781 85177 754 9

Library of Congress Control Number 2013935515

10 9 8 7 6 5 4 3 2 1
2016 2015 2014 2013

A catalogue record for this book is available from
the British Library.

Front cover: Chris Ofili, *After the Dance*, see page 74
Back cover: Maria Magdalena Campos-Pons, *Untitled*
(detail), see page 89
Frontispiece: Faith Ringgold, *Sunflower Quilting Bee at
Arles*, see page 54
Page 29: Renée Green, *Commemorative Toile*, see page 52
Page 125: Margo Humphrey, *The History of Her Life
Written Across Her Face*, see page 84

Designer: Oscar & Ewan
Copy-editor: Denny Hemming

New photography by the V&A Photographic Studio

Printed in Hong Kong

V&A Publishing

Supporting the world's leading
museum of art and design,
the Victoria and Albert
Museum, London

Contents

'SO MUCH THINGS TO SAY'

Prints from Africa and the Diaspora
Gill Saunders and Zoe Whitley

They got so much things to say right now;
They got so much things to say …[1]
Bob Marley

The title of this essay comes from a Bob Marley protest song, in which he admonishes the listener not to forget 'Who you are and where you stand in the struggle', and name-checks heroes of the fight for black rights, the Jamaicans Marcus Garvey and Paul Bogle. Marley's work, driven by his own profoundly hurtful experiences of discrimination from both sides of the racial divide in Jamaica (his father was white), was attuned to a sense of 'outsiderness', of a unique otherness. His music was political in the widest sense, engaged with problems of personal identity, racial identity and resistance to oppression. The artists whose work is collected here have themselves 'so much things to say': some overtly political (challenges to apartheid, to institutional discrimination or exclusion, calls to active protest and empowerment, accounts of injustice, violence and oppression); some asserting rights (the right to speak, to be seen, to belong, the right to be different but equal); others simply offering a perspective from personal experience of being black in a world in which whiteness has for so long been the benchmark for talent, beauty and validity.

Some of those included in this book might baulk at the implied categorization. A book that has 'blackness' (or 'African-ness') as its primary criterion for inclusion undoubtedly enters dangerous territory. It is at risk of perpetuating, or normalizing, a segregation that many of these artists have actively resisted in the art world (pp.118–19); at risk of applying divisive or discriminatory criteria to work by black artists, indeed of reviving the contested category of 'black art' and rehearsing once more all the debates the subject attracts. 'Africa' is itself a problematic term suggesting a unity of practice and purpose that cannot apply to a vast continent of such complex racial, cultural and political diversity. By bringing these artists together – and the selection is itself somewhat arbitrary, since it is dictated by what the V&A has collected over the past 40 years – we are privileging place of birth, ancestry or race above the individual's various allegiances, influences and identities, and are in danger of forcing diverse artworks made in many countries, by artists young and old over four decades, into a straightjacket of race and diasporan politics.

Nevertheless, it seemed to us that there was sufficient common ground – at least among those artists using print – to justify bringing them together and thereby to explore some of the issues raised in and by the work. And it is the use of print media here that is crucially important. More than simply an arbitrary unifying factor, it is print that more often than not ties these works to a shared history. There is a long tradition of print as both a public art and a political art, infiltrating the public arena and playing a part in the sharing and exchange of ideas and information. In Europe from the late medieval period printed ballads and broadsheets, peddled by itinerant street sellers, were part of a public dialogue about newsworthy events, religious belief, morality and politics. Cheap, accessible and topical, such prints enjoyed a wide reach. In the eighteenth and early nineteenth centuries political and social satires in the form of cartoons and caricatures circulated in much the same way, and were available from print sellers. The windows of print shops in London displayed newly published works, where they were a source of entertainment for those who could not afford to buy them, and even for those who were illiterate but could nevertheless recognize a monarch

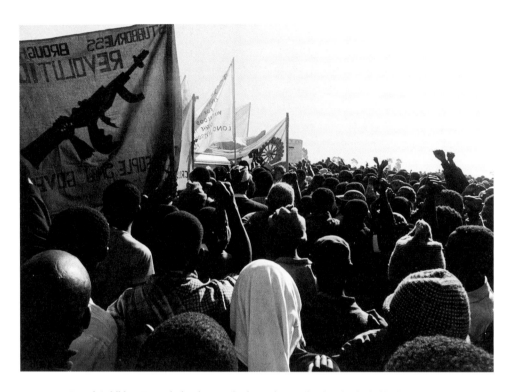

1. David Goldblatt, *Funeral of trade union leader Andries Raditsela, who died of 'unknown causes' shortly after release from detention in the hands of the Security Police, Tsakane, Brakpan, South Africa*, gelatin silver print, 1985. V&A: E.111–1992; gift of David Goldblatt, 1987

or a politician lampooned in exaggerated guise. In the nineteenth century with the appearance of letterpress posters and notices, and the rise of lithographic advertising posters, print became an increasingly visible presence in public spaces. In the later twentieth century, alongside the proliferation of corporate advertising there was also a subversive, unsanctioned colonization of public space by fly-posted printed matter. This proved to be an effective strategy for the anonymous, the impoverished or the illegal, and the tactic has often been adopted by those who otherwise have no public voice, as well as by those ranged against entrenched economic or institutional power, artists as well as activists. Posters and printed banners have also been vital accessories to public protest, utilized by striking workers, student revolutionaries, Civil Rights campaigners and anti-war protestors as well as political activists (fig.1).

The virtues of print for those with a political agenda were enumerated by the sculptor and printmaker Elizabeth Catlett, who argued that if 'we are to reach our audience in the United States, in Latin America, in Africa … we must develop a public art, that is easily transported, easily exhibited, easily reproduced.'[2] Indeed she made the distinction between the two different media in her own practice; where her sculptures were focused on 'the relation between form and emotion', in printmaking she was 'trying to get a message across'.[3]

If the axiom of 'art for art's sake' still applies to Western/European art, it is certainly not applicable to African art. I believe it never has been. For African artistic expression whether rock painting or bronze sculpture, work songs or war dances, never transcended either the physical or cosmic reality of the African people. African works of art appear meaningless unless seen in relation to Africa's cultural and historic reality. It has always been art for life's sake. The environments of today's Africa demand liberation from inhumanity. Can the art of Africa ignore this demand? Can it be anything else than art for liberation's sake?[4]

Gavin Jantjes wrote this in 1978, while living in Hamburg where he was studying. Though he later returned to his native South Africa, he left again in 1982 for what was to be a prolonged period of exile in Europe after the controversy stirred by his uncompromising anti-apartheid stance, expressed in screen prints and posters. His work reflects his wholehearted commitment to the fight for liberation, encompassing the caustic reportage style of *Freedom Hunters* (p.112), the celebratory spirit of *Zulu, the Sky Above your Head* (p.36) or the straightforward political campaigning of his posters (made with photographer George Hallett in London) for SWAPO (the South West African People's Organization), calling for Namibian independence (fig.2).[5] For Jantjes print was a vital tool in breaking the colonial 'culture of silence' in which oppressed peoples had no voice. In 1974–5 he published *A South African Colouring Book*, a suite of 11 poster-type prints, which unite image and text in the style of a child's colouring book, though the subject matter is anything but childlike; screen-printed collages of photographs, text, newsprint, drawings and stencilled text explore and condemn apartheid's precise calibration of colour and race as used to privilege the white minority over the black majority. On the most personal page, 'Classify this Coloured', he shows his identity pass, which designates him as 'Cape Coloured' and includes a picture of himself with an Afro hairstyle – a reminder that in the United States Black Power campaigners (under the slogan 'black is beautiful') were choosing to wear their hair this way as a symbol of pride as well as political allegiance. *A South African Colouring Book*, originally produced in an edition of 20, was later supplemented by a small-scale reproduction of the portfolio, which enjoyed a wider distribution (fig.3).

Though many artists – white and black – played safe with art that ignored 'everyday injustices and inhumanity',[6] Jantjes was not alone in using print to promote an anti-apartheid rhetoric and to highlight the abuses of the system. Nils Burwitz made a number of prints that pictured the language of discrimination and exclusion to telling effect (pp.31 and 113). Sue Williamson, who moved to South Africa as a child in 1948, was to become a powerful advocate for the cause. Her magnificent series *A Few South Africans* (1983–7; pp.115–17) was an attempt 'to make visible the history of women who had made an impact in some way or other on the struggle for freedom'.[7] At the time, these women and their activities were little known; to make their portraits Williamson used photographs she took herself or sourced from banned books unearthed in university libraries. Using a mix of print

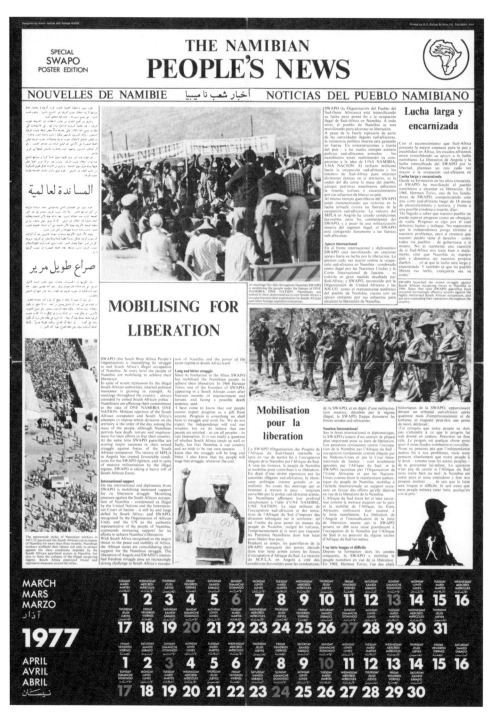

2. Gavin Jantjes and George Hallett, *SWAPO The Namibian People's News*, poster for Namibian independence incorporating a calendar for March/April 1977, published London, 1977. V&A: E.1089–1993

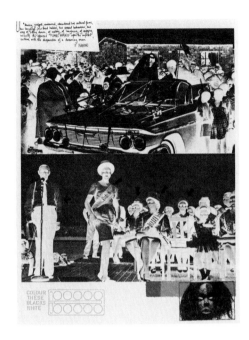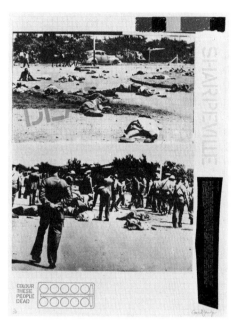

3. Gavin Jantjes, two plates from *A South African Colouring Book*, colour offset litho, published in Hamburg, 1978; from a reproduction of the original portfolio of 11 screen prints, published in Hamburg, 1974–5. V&A: National Art Library NL.94.0403

techniques – photo-etching and screen-print collage – each photographic image was given an elaborate decorative frame, a reference to the way in which people in squatter towns and townships used scraps of wallpaper and printed packaging to enhance simple snapshots, elevating them to the status of small-scale works of art. Moreover, as she has explained, 'An important part of this series is that they were reproduced as postcards, in order to make the images widely accessible to a general public.'[8] According to Williamson, these were described as 'one of the most important icons of the eighties'; they were eagerly collected by those who could never afford the original prints, and had an emotional value for many who supported the cause of liberation. So, again, print enjoyed two levels of distribution: prints from the editions[9] were seen by a limited audience of mostly white gallery visitors and collectors, while the mass-produced postcards reached into wider society.

Printed banners and posters were of course features of the political landscape in South Africa during apartheid, promoting and protesting causes for organizations such as COSATU (Congress of South African Trade Unions) and the ANC (African National Congress, then the leading opposition party; see fig.4). In fact the role of art in apartheid South Africa was discussed within the ranks of the ANC; some held to the Leninist view that art must be a weapon of struggle, a tool to be used against capitalism, of which apartheid was one of the most egregious symptoms. But others felt that pressing art into the service of a political cause could only result in 'an impoverishment' of that art. The lawyer and human rights activist Albie Sachs argued (in 'Preparing Ourselves for Freedom')[10] that political motivation

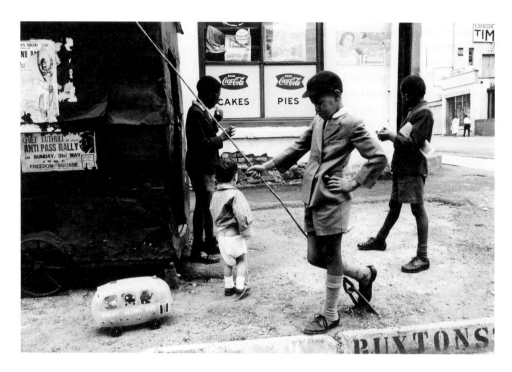

4. David Goldblatt, *Steven with Bus, Doornfontein, Johannesburg*, gelatin silver print, 1960.
V&A: E.5–1992; gift of David Goldblatt, 1987

inevitably had a distorting effect, suppressing a natural spirit of optimism, of 'fun, and romanticism and dreams'. For Sachs this spirit survived undimmed in music but was being crushed out of other forms of creative expression: 'Pick up a book of poems, or look at a woodcut or painting, and the solemnity is overwhelming.' Perhaps conscious of such dangers in addressing the iniquities of apartheid head on, certain artists preferred an oblique, allusive approach: William Kentridge has said, 'I have never tried to make illustrations of apartheid' but acknowledged that his works 'are certainly spawned by and feed off the brutalized society left in its wake. I am interested in a political art, that is to say an art of ambiguity, contradiction, uncompleted gestures, and uncertain endings; an art (and a politics) in which optimism is kept in check and nihilism at bay.'[11] Indeed in prints, as in his films and drawings, nuanced unresolved narratives can usually be traced back to South Africa, though their starting point may seem to be elsewhere. For example, Kentridge recognized parallels with a contemporary Johannesburg in the Trieste of writer Italo Svevo's hero Zeno (his novel *Confessions of Zeno* never travels beyond the confines of the Italian town) (p.57).

The role of printmaking in the political discourse of southern Africa – Namibia, Botswana, Zimbabwe, and South Africa in particular – is noteworthy, not least because print is not an indigenous African art form. It had been introduced largely by European artists and missionaries, through workshops and art schools where European techniques – first linocut and woodcut, later etching, screen print and lithography – were adopted for distinctively African interpretations of subjects such as Bible stories; or nostalgic evocations of the local landscape, flora and fauna;

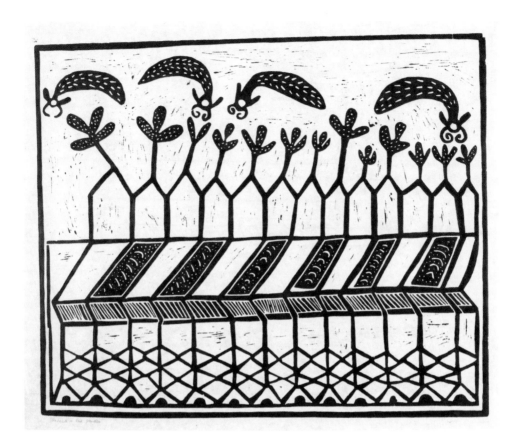

5. Thamae Setshogo, *Insects in the Garden*, linocut, 1993. V&A: E.729–1993

or subjects drawn from 'the customs and manners of life of my own people' in the words of Thamae Setshogo,[12] who draws on his San heritage to express aspects of indigenous southern African culture (p.40). Of these print techniques, the one most widely taken up, at least by the first generation of African practitioners, was linocut. Lino offers many advantages, being a simple process, easy to learn, and needing no special skills or technical knowledge; it requires only a few affordable portable tools and materials, and it can be worked quickly to produce bold and effective graphics.

A distinctive style of linocut printing was practised at community workshops and arts centres, beginning with the Rorke's Drift ELC Art and Craft Centre (established in 1968, in Kwazulu-Natal), where artists such as John Muafangejo (p.79), Azaria Mbatha and Paul Sibisi (p.33) acquired international reputations. The technique evolved under the auspices of the Kuru Development Trust in D'Kar, Botswana, where the prolific Setshogo (fig.5) was among those who developed a signature style and subject matter, employing motifs derived from traditional decoration on ostrich-shell containers, wooden utensils and glass beadwork. Elsewhere, those artists – such as the Nigerian Uzo Egonu (p.45) – who attended art schools in Europe developed a sophisticated synthesis of African motifs and mannerisms with European modernist strategies blending elements of Cubism, Surrealism and abstraction. Their work may not be explicitly political (though

profits from the Kuru Art Project are used to support the continuation of the traditional livelihoods of the San peoples) but it shows a determined attachment to a personal vision inflected by historic precedents, such as San rock carvings, and by traditional arts and crafts – the patterning of cloth, baskets and other products of culturally-specific design. Nor were the artists working in ignorance of, or isolation from, contemporary political ideologies. Those at Rorke's Drift, for example, were shaped by the Black Consciousness movement founded by anti-apartheid activist Steve Biko, an influence reflected in an awareness of, and pride in, black African culture, values and religion.

As a process linocut has itself been given a political identity. Describing its adoption in Africa, through the mediation of Swedish missionaries, and its link with the German Expressionists, whose works were informed by Cubism and the debt to African sculpture, William Kentridge saw 'a kind of circularity', concluding that 'lino-cutting corresponds to anti-colonialism, certainly in Southern Africa.'[13] In the United States Elizabeth Catlett, who has consistently used her art as a tool in the struggle against injustice, has also espoused the linocut, and has said that she makes 'linoleum prints because this is a suitable medium for public art – easy and inexpensive and you can make the edition[s] as large as you need them.'[14] And of course linocut, with its similarities to woodcutting and woodcarving, has been regarded as being closely connected to indigenous African arts and crafts.

Willingly or otherwise, black artists often attract readings of their work that assume an underlying political purpose, or more specifically a message predicated on racial difference. Carrie Mae Weems has spoken about this in relation to her own practice. In 1989 she was quoted as saying, 'my primary concern in art, as in politics, is with the status and place of Afro-Americans in our country'.[15] Ten years later, when questioned about this statement, she explained the challenge of being understood on her own terms:

> The thing I'm most interested in at this moment is the complexity of human experience and relationships, be they African American or otherwise … My sense was that images of white people could speak about universal concerns. I wanted to use images of blacks in the same way, so that representations of blacks could stand for more than themselves and for more than a problem, that they could speak about the human condition. But I've come to realise that the way blacks are represented in our culture makes it almost impossible to get that point across. So, now I'm asking questions in a different way. Notions of black representation are still very important to me, and will always be a concern. In fact it is now absolutely my assumption that people of color do speak to something bigger than themselves. I assume that is just fine, whether writers and critics get it or not – it's not my problem. If they don't get it then my work is misunderstood and racialized.[16]

But if Weems has resisted assumptions that reduce her work to a simplistic address to racial politics, others have acknowledged issues of race as having had

a real impact on the direction of their work. Kerry James Marshall is one of a number of African-American artists who have spoken of a sense of responsibility, of obligation even, to take a political stance in their art. As he has said of his own experience:

> You can't be born in Birmingham, Alabama in 1955 and not feel like you've got some kind of social responsibility. You can't move to Watts in '63, and grow up in South Central near the Black Panthers' headquarters and see the kinds of things that I saw in my developmental years and not speak about it. That determined a lot of where my work was going to go.[17]

Now living in Chicago, Marshall has espoused protest and community politics through such means as his comic-book character Rythm Mastr, a black superhero who has featured in a number of print formats including billboards, magazine inserts and paper coffee cups (p.120).[18]

But whereas certain artists of the diaspora, such as Weems, Marshall and Renée Green, have used their work to speak to and of 'the black experience', others, notably Frank Bowling, have explicitly rejected the idea as limiting. As a painter, Bowling has chosen abstraction, and has achieved a series of 'firsts' in establishment acceptance for black artists, but has only rarely involved himself in the more democratic medium of printmaking (p.73). Bowling was much influenced by American Abstract Expressionism, which was instrumental in his decisive shift from figuration to abstraction, whereas an earlier generation of black artists in the United States had found the Abstract Expressionists wanting in their failure to address social and political issues; the muralist Charles White condemned them for 'thumbing their noses at society and speaking an esoteric language'[19] and dismissed their work as being 'devoid of anything to believe in'.[20] He felt that artists – especially black artists – had an obligation to use their work to debate political issues as well as aesthetic concerns. As he said, 'If we accept the premise that this is a racist society, then there can be no Black art or scholarship that can be non-political.'[21] For White as for many black artists, then and now, abstraction was a luxury, a personal indulgence, that was largely irrelevant until battles against injustice and discrimination had been won; and artists were of necessity activists in those battles, with their work as their weapon.

This was literally so for those such as Emory Douglas, an artist whose distinctive graphics became synonymous with the Black Panther Party, a controversial offshoot of the Civil Rights and Black Nationalist movements in the United States, established in 1966. Douglas, the Black Panthers' 'Minister of Culture', single-handedly created the party's strong graphic identity, spelling out its ideology and its political and social agenda (pp.105–9). He illustrated every issue of the party's weekly newspaper, using the commercial typography and illustration skills he had learned at a print shop while in juvenile detention for burglary. Describing his images he has said that 'since the black community at that time weren't by and large readers,' he 'created an "everyperson" look everyone could identify with'.[22] His style, applied so effectively to posters and manifestos as well as to newsprint, has echoes of the work of those African-American artists he admires, namely Charles White and Elizabeth Catlett. Drawing with thick black outlines in a manner that

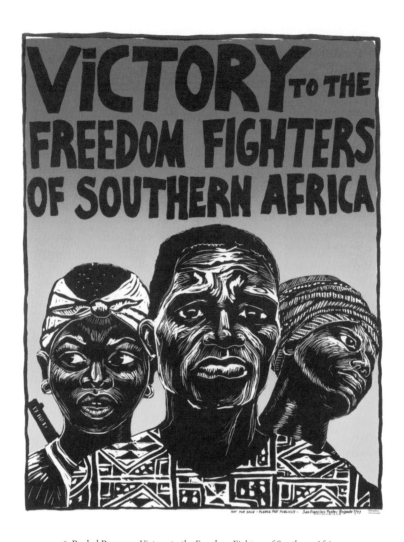

6. Rachel Romero, *Victory to the Freedom Fighters of Southern Africa,*
poster issued by the San Francisco Poster Brigade, published San Francisco, 1977.
V&A: E.340–2004; gift of the American Friends of the V&A; gift to the American Friends
by Leslie, Judith and Gabri Schreyer and Alice Schreyer Batko

imitated the graphic simplifications typical of woodcut and linocut, he also looked
to Chicano posters of the 1960s and 1970s (fig.6). Above all, he used print to show
'in which direction the party was headed', aligning it with a resistance to all forms
of repressive authority. The Panthers also used simple stencilled graphics for
distribution to students, designed to appeal to white liberal sympathizers among
the student radicals on university campuses (fig.7).

Such was the appeal and efficacy of Douglas's imagery in engendering
support for party causes that it was covertly appropriated by the Federal Bureau
of Investigation's counter-intelligence programme (COINTELPRO). In a series
of memoranda to various field offices where black nationalists had grassroots
support, Herbert Hoover solicited 'imaginative and hard-hitting' measures to
discredit and divide the movement.[23] A particularly effective tactic involved
creating crude forgeries suggestive of Douglas's raw style. Depicting prominent

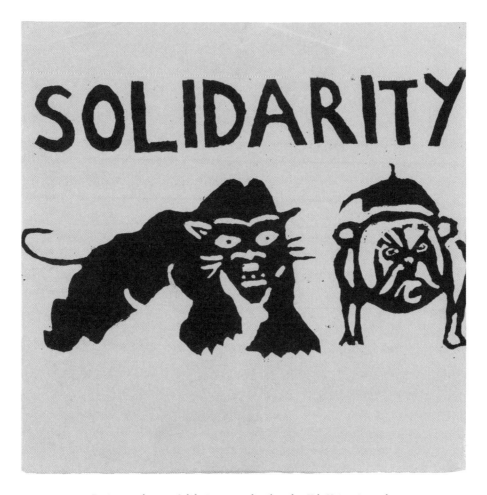

7. Designer unknown, *Solidarity*, poster distributed to Yale University students
in support of the Black Panther Party, published United States, 1970. V&A: E.1436–2004;
gift of the American Friends of the V&A; gift to the American Friends by
Leslie, Judith and Gabri Schreyer and Alice Schreyer Batko

activists, often labelled by name to remove any ambiguity, these were circulated
in a number of deliberately inflammatory contexts, which promoted animosity
between other activist groups with whom the Panthers had formed alliances (the
Student Nonviolent Coordinating Committee and fellow Black Nationalists, United
Slaves, among key targets). These cartoons, posing as official Panther propaganda,
manipulated the more controversial elements of their ten-point plan, thereby
distorting the emphasis on self-defence and self-determination in order to suggest
outright calls for violence and racial hatred. The extreme views presented in these
forgeries divided the Panthers and distanced moderate supporters – both black and
white – who accepted the illustrations as fact. The distinctive look and wide reach
of the BPP's printed matter was ultimately used against the party.

While Douglas's posters undoubtedly had an impact, the influence of print,
with its declared political agenda, is often overstated. Prints and posters, even those
made in the white heat of anger and activism, in response to the momentum of
events, often gained their iconic status long after the events that generated them

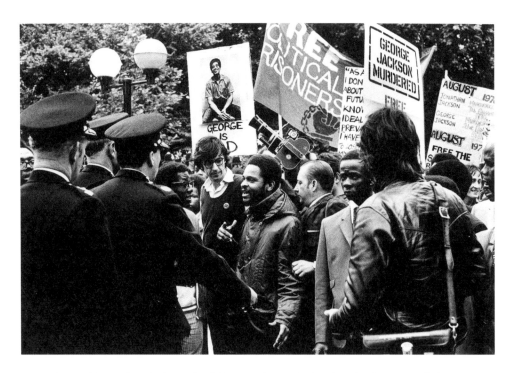

8. Dennis Morris, *George Jackson is Dead, Grosvenor Square, London*, from the *Growing Up Black* series, gelatin silver print, 2010, from original negative, 1970. V&A: E.1487–2010

had passed. Printmaking, as Judith Hecker has demonstrated in her 2011 book *Impressions from South Africa: 1965 to Now*, has undoubtedly been a means of articulating resistance and dissent, and 'a catalyst for change'[24] in that country, during and after the years of apartheid rule. More often, though, it is the case that the prints themselves merely commemorate rather than instigate; they address the aftermath and only rarely do they change the world at the time. Llewellyn Xavier's screen prints inspired by George Jackson, a United States prisoner and member of the Black Panthers (p.110), created as powerful arguments in support of demands for Jackson's release from prison, have often been cited as politically engaged pictorial activism but in fact they were published a year after his death, coming almost as a postscript to the protests in the United States and in London (fig.8).

Artists such as Faith Ringgold, Margo Humphrey, Adrian Piper and Petrine Archer-Straw (fig.9) address a broadly feminist agenda, often through the prism of personal experience or the use of the self-portrait, making richly allusive prints that mine the history of art for references and parallels. Ringgold puts African-American history back into the picture, in the process alluding to the singular achievements of black artists, often unacknowledged, such as the quilt makers of Gees Bend (p.54). She has also made prints – silk-screened illustrations – that tell the story of the Civil Rights struggle through the writings of Martin Luther King. Humphrey, whose work juxtaposes the personal and the political,

18

9. Petrine Archer-Straw, *Page Six*, colour screen print, 1988. V&A: E.1237–1995

has worked exclusively in print, and sees it as a medium for making a difference. In a 1981 lithograph, *Nectarines and Oranges on My Mind*, Humphrey name-checks artists and writers who have inspired her: 'Richard Write [*sic*] Sonya Sanchez Betye Saar Stevie Wonder Elizabeth Catlett …', and concludes 'We turned little black Sambo into a hero [!] we changed the story!' Of another print, *The History of Her Life Written Across Her Face* (p.84), she has said, 'The image is about empowerment and the projection of oneself forward, about oppression as a vehicle for self-expression, and about the physical and inner beauty of African American women.'[25] The dissemination of such images as prints, themselves reproduced

(*The History of Her Life* … was then used for an exhibition poster), was a valuable contribution to 'consciousness raising', originally a strategy of 1970s feminism, but one that widened to include awareness of other forms of inequality and discrimination, not least racial. For Humphrey, like other black female artists, did not find the women's movement to be fully inclusive, or supportive.

It is this personal experience, and an awareness of difference and discrimination, that underlies many of the works here, such as Maria Magdalena Campos-Pons's untitled print in which the black female body (her own) is the self-conscious object of a controlling scrutiny (p.89). It has also informed much of Sonia Boyce's work, which has engaged with an identifiably 'black' culture, especially music. However, Boyce has argued that identity has been 'overemphasized' as an issue for black artists, and has objected to the limitations such expectations place on her as an artist, saying, 'Why should I only be allowed to talk about race, gender, sexuality, class? … I want to find out what other things I can talk about. I no longer want to describe who I am.'[26] Boyce has worked in a range of media, beginning as a painter, but print – stand-alone or as part of an installation or the product of a collaborative process – has been the medium for some of her most subtle and resonant work. Deploying word as image, she has made wall-sized prints on lengths of wallpaper, which exploit the properties of 'wall-paper' with its allusions to the domestic, and thus to women's lives, but also refuse the conventions of repeating pattern (p.72). They draw on black culture and history, without being overly focused on the specifics of race or personal identity; rather they explore concepts of public and private, absence and presence, visibility and invisibility.

For others, notably Kara Walker, Carrie Mae Weems, Glenn Ligon, Ellen Gallagher and Kerry James Marshall, questions of black identity – and black visibility – have been fundamental to complex and sometimes controversial imagery. These artists and many of their peers – including Chris Ofili and Isaac Julien in Britain – have tackled degrading or demeaning racial stereotypes head-on, underlining the offensiveness of the originals with irony or excess in order to reclaim them. For some, including an older generation of artists such as Elizabeth Catlett, and others who lived through the Civil Rights era, these strategies are uncomfortable at best, too readily recuperated from the prejudice that spawned them in the first place. Walker in particular has been criticized for confronting subjects that have been considered by many to be taboo in American society. The racially specific caricatures that people her work are drawn from advertising and other such popular print imagery of a kind now considered unforgivably offensive, needlessly provocative, presenting painful parodies of black bodies, and their abuse. Walker would argue that the figures are revived in her work to force her audience to recognize that such caricatures have not been safely forgotten, but remain embedded in the contemporary subconscious of blacks and whites alike, feeding prejudice, poisoning race relations and enduring as a spectral presence in American society (p.72).

Willie Cole has also drawn on advertising for complex, layered works that allude to African art and its spiritual and cultural heritage, the history of the slave trade,

and black women's domestic servitude. Visual puns and word play characterize his adaptations of the domestic iron, used both as a recurrent motif in his work and often as a tool, the iron employed to burn images onto cloth and paper. A series of large-scale Iris prints features irons seen from above, digitally stripped of their flexes, labels and so on. Their forms clearly allude to African masks but the manufacturers' advertising slogans, adopted by Cole as his titles, conjure older advertisements extolling the virtues of slaves for sale: *Loyal and Dependable* (p.56), *Quick as a Wink* and *Satisfaction Guaranteed*. Questioned about the political intent of his work, Cole has claimed 'Every action is political and spiritual, as well as physical, of the moment.'[27]

Cole's work connects to an African heritage as a marker of African-American identity; Carrie Mae Weems, in her narratives, repeatedly addresses the question of personal identity – as a black woman artist – of the kind Sonia Boyce has largely disavowed. In a photographic odyssey, and the wallpaper which accompanied its display,[28] Weems has been 'looking high and low' to understand her own history, her place in the wider world. In particular, she has explored the complexities of her relationship with cultural institutions such as museums, with their discredited habit of demeaning African art as ethnography; their long exclusion of black artists from their collections, or their presentation of a single history which speaks to, and of, only 'white' culture.

Weems takes back John Farleigh's figure of a naked black girl in the jungle (p.86), as if to say, 'that's not yours, it's mine'. Renée Green and Kerry James Marshall have similarly used 'white' imagery such as toile de Jouy patterns, putting black actors back into the narrative of eighteenth- and nineteenth-century history, re-inscribing a black presence where it had been erased. Fred Wilson's work, most famously *Mining the Museum* (an installation at the Maryland Historical Society, Baltimore, 1992–3), has shown us how completely and unthinkingly the evidence of black lives has been expunged from the record, or hidden, in our cultural institutions. Indeed, the V&A has only recently acknowledged that it holds a variety of arts and crafts from all parts of the African continent; hitherto much of this material had languished unrecognized or undocumented. In some cases, unpalatable truths about the circumstances of the acquisition – the fruits of conquest and looting – have fostered this institutional silence, and this is something to which Hew Locke has often alluded (p.60). In fact, prints and posters have been the most visible and accessible evidence of the V&A's engagement with Africa and its diaspora, thanks to a proactive and prescient collecting policy pursued by our curatorial predecessors.

The tendency of European artists to 'exoticize' their borrowings from Africa, or to view African people and their art as inherently 'primitive' (in the sense of natural, innocent and unspoiled, or savage and ignorant), has spurred artists in Africa and the diaspora to reclaim and reconfigure these stereotypes. Tony Phillips does this when he shows the looted Benin bronze heads as the equivalent of living trophies, like slaves, or later the pygmies and others who were brought to Europe and America to 'perform' their culture for public display (pp.48–51). In Phillips's version of their history the bronzes have the dignity and individuality of fully realized human subjects, while their 'captors' – the auctioneer, the academic, the

art collector, the museum visitors – are reduced to shallow, sketchy caricatures. Implicit in Phillips's revisionist narrative is a critique of an art world predicated on a belief in the innate superiority and sophistication of Western art, a canon of achievement to which African art can only be admitted in certain circumstances. As the Ghanaian artist Atta Kwami has said, 'All too often, opinion-makers from the West see their own art in innovative terms while African art is inauthentic unless it can be seen to be rooted in tradition. Why not reverse the assessment and judge Western Art by its authenticity and African Art by its originality?'[29] (p.41).

This question gives rise to the vital consideration of how we define art and artists today, and of when, or if, we can cast aside factors such as gender or ethnic background in favour of allowing art to 'speak' for itself. With the former, the traditional art historical notions of art revealed through formal analysis have shortcomings, as Kwami suggests, not least of cultural bias. The latter assumes a level of understanding and homogeneity of audience that can be exclusionary and a degree of artist experience that can prove limiting.

The term 'post-black' gained currency as a means of highlighting a new generation of artists of African descent whose varied practices might carry few or no racial signifiers (for practitioners choosing to work in abstraction, installation or purely formalist conception), or whose practices bear hallmarks of identity in order to reveal complex, nuanced and possibly ambivalent relationships to race. These artists understood that critical reception of their blackness could limit discourse, even as the works they created were often informed by their appreciation of the realities and absurdities of race.

The Thelma Golden and Christine Y. Kim 2001 exhibition of the work of emerging artists, *Freestyle* (Studio Museum, Harlem), which showed work from a younger generation whose concerns were considered 'post-multicultural, post-identity, post-conceptual, and post-black', was decisive.[30] These artists were not so much reflecting a time after blackness as the fact that their blackness was just one aspect of self-expression that they wished to address.

Such concerns are hardly new. Since the late 1960s Adrian Piper has focused on the intersection of life, art and identity (pp.81–3). Piper transformed the ubiquitous business card of the 1980s into a social statement with *My Calling (Card) #1* (1986). Printed to fit conveniently into a wallet or pocket, it declares with sardonic wit:

> Dear Friend, I am black. I am sure you did not realize this when you made/ laughed at/agreed with that racist remark. In the past I have attempted to alert white people to my racial identity in advance. Unfortunately, this invariably causes them to react to me as pushy, manipulative, or socially inappropriate. Therefore, my policy is to assume that white people do not make these remarks, even when they believe there are no black people present, and to distribute this card when they do. I regret any discomfort my presence is causing you, just as I am sure you regret the discomfort your racism is causing me.[31]

The card appeared in versions both signed by the artist and unsigned for others to distribute in appropriately inappropriate circumstances under a sign bearing the words, 'JOIN THE STRUGGLE TAKE SOME FOR YOUR OWN USE'.

The emphasis on the ideological constructs of race and identity that informs much of Piper's conceptual and philosophical framework has at times overshadowed critical considerations of other matters at play in her work. Her 2003 open letter, 'Dear Editor', enumerates:

> Please don't call me a black artist.
> Please don't call me a black philosopher.
> Please don't call me an African American artist.

Followed thereafter by 85 further permutations of privileging her race and gender above her profession, she concludes:

> I have earned the right to be called an artist.[32]

Certainly all the works in this book tell many artists' stories simultaneously. Chris Ofili, who grants few interviews and only rarely explicates sources or meaning in his own work, has said, 'Somehow through the exploration of race you can get to a new place, a new form of understanding. Somehow maybe we can even exploit the misunderstandings'.[33] Ofili frequently subverts any attempts at a single reading of his work, never more notoriously than when incorporating elephant dung into an image of the Virgin which has variously been misconstrued as sacrilege (it isn't) or misattributed as having a direct cultural significance to his heritage (it doesn't). It is still often difficult for black artists to be judged on their own terms, to be artists *and* black without the former being framed in terms of the latter.

The fact remains, however, that when race and gender go unstated the normative assumptions are of whiteness and maleness. Writer Zadie Smith has sought to redress this unstated assumption by specifying whiteness rather than 'otherness':

> It's an existential point.[…] It's beyond politics. I decided the only race I was going to mention was white people, so anyone who's white is identified consistently. I suppose I want to show a world in which people who are not white are not determined by white people. And it proves to be incredibly hard to do that. You realise if you grow up black in England that to a lot of people here being black is in itself a political statement. But we're neutral to ourselves, you understand.[34]

Smith's 'neutralizing' strategy is noteworthy in this context because it is shared by British writer and painter-printmaker Lynette Yiadom-Boakye (p.103), who depicts predominantly black subjects as the unremarkable and uncontrollable result of 'only being able to speak from my own point of view, informed by who raised me, what colour I am, what religion I am and what gender I am. All these things influence what I do, but wouldn't it be stranger still if everyone in [my work] was white? What would that say about me? Isn't the bigger question why blackness isn't considered normal? I don't find black people weird to look at, I don't find black people exotic.'[35]

And yet the mere presence of race can make for politicized readings where none exist. Ellen Gallagher (p.96) has said:

If you see yourself as the only black [art] student in an all white school then you are always making work that is circumscribed – even if it's naughty or 'political' it's for a white audience. By the time I started showing my work in museums I was already a member of a complex art community ... For me the use of subtlety in my work is about a refusal to be in an overly determined theatrical relationship with an audience.[36]

The assumptions can cut both ways. Not only can critics and historians overemphasize cultural signifiers at play in artworks but artists can also predetermine their audience. What happens when the 'Editor' to whom Piper addresses her criticism is also a woman and/or black? Laylah Ali, who attended the prestigious Skowhegan artists' residency programme (established in 1946 in New York and Maine) the same year as Gallagher, also questions the effects of over-determining one's audience. In an interview with Kara Walker, Ali revealed:

I always thought that Adrian Piper, at least in one period of her career, had a concrete idea of who her audience seemed to be – the affluent white museumgoer or some version of this, with 'white' and 'affluent' being key identifiers – and it always bugged me because I didn't feel part of that intended audience. I thought: I am here too, and I also need to be addressed by your intelligence and insight.[37]

Indeed, sometimes a clear articulation of an artist's identity serves not to amplify differences or otherness but instead to create an affinity, drawing connections between artists and building rapport with black audiences who still all too infrequently see themselves represented in art or within the art spaces of museums and galleries. Carrie Mae Weems noted, 'I can spend an evening at most art functions in New York City and not see a single other person of color. Now. Today. That's shocking to me.'[38]

Let us turn now to the important, but often overlooked, role of printed text across the field of artists' works on paper. Word play not only manifests itself in the titles (as in the work of Willie Cole, John Lyons and Winston Branch, for instance) but also in a more literal form: appropriating printed text as inspirational source material, supporting artistic messages with factual text, or using the formal qualities of verse and literary passages to create visual compositions. Text is embedded – legibly or otherwise – in many of the prints featured here. Extracts from letters and newspaper headlines piece together the life and death of George Jackson in the prints of Llewellyn Xavier; handwritten fragments of autobiography animate Margo Humphrey's self-portrait; lines from the Bible caption the vignettes of Noah's ark in John Muafangejo's linocut and street signs demarcate the zones of apartheid in Nils Burwitz's prints; in Sonia Boyce's wallpaper blind-embossed song lyrics embody the meaning of the work.

With posters, graphics are often subservient to an explicit informational message, with text often bearing more weight than any attendant image. This is true in the case of stickers, flyers and leaflets produced by PESTs, an anonymous

New York-based collective of artists who used the sobering statistics of unequal representation of black artists and other practitioners of colour in museums and commercial galleries to confront the institutional racism of the art world: a newsletter in the form of a menu is headed 'The Following New York City Galleries are 100% White' (p.118) and a slip of paper carries the single question, 'How often do you see a one person show by an artist of color?'

The presence of text most often supports the image by providing a few key reference points to guide the viewer. A seminal example in the V&A's collection is a series of wash drawings collectively titled *A Fashionable Marriage. Marriage à la Mode* (1986) by Lubaina Himid. These works served as aides-memoire to her realization of a scathing installation of painted plywood figures, taking its title from William Hogarth's 1743 tableaux of the hubristic and ruinous excesses of eighteenth-century London high society. Himid reworked Hogarth both as an institutional critique against tokenistic black presence and as a contemporary indictment of British arts policies for alienating many artists.

Hogarth's original cultural commentary was therefore updated to reflect the socio-cultural concerns of Britain in the 1980s. Himid has devoted her work, primarily in painting, to exposing hypocrisy and exclusion in British society, particularly within the arts (figs 10–11). 'It was important to find a way of revealing this rather obvious political reality while at the same time showing how it was linked to a middle-class, complacent, liberal intellectual art community, which through newspapers like the *Guardian* and institutions such as the Arts Council pretended to be the opposition. Being an advisor on various arts panels gave me a unique insight into the workings of this complicated, many-layered world.'[39] Hogarth's six satirical paintings enjoyed widespread popularity as engravings, his first series of moralizing prints. The scenes chronicle the avarice and ethically dubious machinations at play in a marriage arranged between two families – upwardly mobile merchants on the one side and titled but penniless on the other – intended for mutual benefit by improving the finances of the latter and the status of the former. The Countess and her lover are transformed into then-Prime Minister Margaret Thatcher and then-President Ronald Reagan. Thatcher's opulent dress is adorned with evidence of her culpability in events such as the miners' strike and rising unemployment drawn from the headlines of broadsheet and tabloid newspapers. Reagan, meanwhile, reclining as would an odalisque figure, is dressed as a cowboy-cum-superhero, extending an invitation to World War Three. The printed text, 'the cowboy rides high', underscores the contemporary update of the characters originally drawn from Hogarth's commentary and references for the audience President Reagan's past as an actor, crowned by the artist as the 'B-Movie President/Cowboy Ruler' (fig.11). Hogarth's attendant envoy becomes for Himid a 'dithering art funder', literally sitting on a fence, vacillating as to whether to support 'the disabled, the black, the women, or wait until someone else gives permission?'[40] This re-staging of Hogarth's *The Toilette*, the fourth scene about arts patronage and conspicuous consumption, includes an African page in the background and a young turbaned slave on the margins of the foreground. While they remain compositionally on the sidelines,

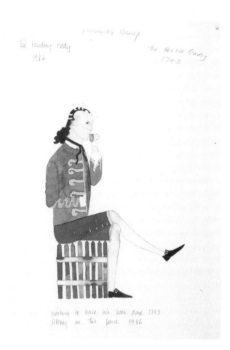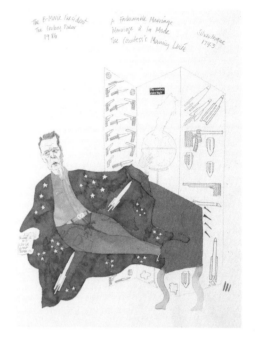

10, 11. Lubaina Himid, *The Funding Body 1986 / The Feeble Envoy 1743* and *The B-Movie President / The Cowboy Ruler 1986 / Silvertongue 1743*, wash drawings with collage; from the series *A Fashionable Marriage. Marriage à la Mode. The Countess's Morning Levée*, 1986. V&A: E.602–1996 and V&A: E.600–1996

they are here recast in the empowered positions of a radical black activist and 'Ka – the spirit of Resistance'.

Text is perhaps at its most transcendent in works by artists such as Glenn Ligon, where words themselves form the basis of the work and text becomes image (p.98). Ligon's signature works are known as 'text paintings' and have the effect of a modern-day illuminated manuscript, where text and image merge. The hand-stencilled letters form an overall aesthetic effect, appropriating quotes from writers including James Baldwin, Ralph Ellison, Walt Whitman, Gertrude Stein or Zora Neale Hurston and pop culture personalities such as actor-comedian Richard Pryor. Ligon has described his stencilling as a 'way to be semi-mechanical, to make letters that are not handwriting but have personality. Handwriting would make these quotations too much mine, and stencils give it a bit more distance.'[41] He has also described his appropriations in cinematic terms: 'The way I use quotations is almost like adapting a novel for a film. It's based in the text, but it's not the same thing. It has its own structures and desires.'[42] The overall effect is both transcendental and immersive: 'At some point I realized that the text was the painting and that everything else was extraneous. The painting became the act of writing a text on a canvas, but in all my work, text turns into abstraction.'[43]

Print can reach far beyond the portfolio: resonant images have been printed on paper coffee cups, as throwaway stickers and flyers, as wallpaper, as pop-up books and comics, as well as posters. Co-opting the age-old strategies of the

broadsheet, the ballad sheet, the cheap popular prints that passed from hand to hand, or appeared like news bulletins in print shop windows, contemporary print – and especially print with a political agenda – has adapted to reach new audiences, to publicize causes, to fight, to agitate, to commemorate and to celebrate. Here we find examples of prints produced as a part of a collaborative process of design and production, through workshops with a community or political agenda; prints commissioned as fund-raisers; prints produced independently as individual expression. Whatever its genesis, each of these images has something profound to say about black culture and experience, and there is often a political dimension, even in those prints which might appear most obviously celebratory as, for example, in the *Jouvert* portfolio, which captures the spirit of Carnival (pp.35 and 68).

Some of these artists are passionate about print, its nature and capacities, working with it as their primary medium; for others it is one option among many. But all have found in it an effective means to a purposeful end. Several have spoken revealingly of their engagement with and experience of printmaking. For Faisal Abdu'Allah, making a print is a ritual process, reflecting a spiritual outlook, and involving prayer (p.69). For Lynette Yiadom-Boakye, her choice of etching is a deliberate allusion to 'the historical depictions of human likenesses'.[44] Trenton Doyle Hancock has written a paean to print, celebrating its perennial attraction: 'the print is smarter than you ever give it credit for. Once you tell it something, it records it in its own specific language and re-broadcasts familiar markings with a new sense of purpose and utility.' He marvels at print's capacity to be 'at once concrete and fleeting ... flesh and machine ... elitist and fully accessible.'[45]

NOTES

1. Bob Marley, 'So Much Things to Say', from the album *Exodus* (Island Records), 1977.

2. Quoted in Samella S. Lewis, *The Art of Elizabeth Catlett* (Los Angeles, 1984), p.101.

3. Quoted in Michael Benson et al, 'Form that Achieves Sympathy: A Conversation with Elizabeth Catlett' in *Sculpture* (April 2003), 22, no.3, n.p.

4. *Gavin Jantjes: Graphic Work 1974/78*, exh. cat., Kulturhuset, Stockholm, 1978, p.7.

5. Other powerful posters supporting independence movements in other African countries – such as Zimbabwe and Mozambique – were produced outside the continent, in the United States and Cuba.

6. Sue Williamson in *Resistance Art in South Africa* (Cape Town, 1990), p.8.

7. Quoted in Artist's Statement (unpublished), supplied by Goodman Gallery, Cape Town, South Africa. No date.

8. Ibid.

9. The earlier prints in the series were produced in editions of 20, some of the later images as editions of 35.

10. Presented first as a seminar to ANC members at a meeting in Lusaka, towards the end of 1989, and later published in the *South African Weekly Mail*, 2 February 1990.

11. William Kentridge in *William Kentridge: Drawings for Projection, Four Animated Films*, exh. cat., Goodman Gallery, Johannesburg, 1992, n.p.

12. Fieldwork interview, 15 June 1995, quoted in Mathias Guenther, 'Contemporary Bushman Art, Identity Politics and the Primitivism Discourse', *Anthropologica* (2003), vol.45, no.1, p.95.

13. Quoted in Judith B. Hecker, *William Kentridge: Trace: Prints from the Museum of Modern Art* (New York, NY, 2010), p.65.

14. Jeanne Zeidler (ed.), *Elizabeth Catlett: Works on Paper, 1944–1992* (Hampton, VA., 1993), p.8.

15. Mel Rosenthal, 'Commentary', in *Nueva Luz 2* (New York, NY, 1989), p.32.

16. Quoted in *Carrie Mae Weems: Recent Work 1992–1998*, exh. cat., Everson Museum of Art, Syracuse, NY, 1998–9, p.12.

17. 'Kerry James Marshall interviewed by Calvin Read', *BOMB* (Winter 1998), 62.

18. Commissioned for *Imprint: a public art project*, The Print Center, Philadelphia, PA., 2002.

19. Quoted in Celeste-Marie Bernier, *African American Visual Arts from Slavery to the Present* (Chapel Hill, CA., 2008), p.128.

20. Ibid.

21. Ibid.

22. Quoted in Jessica Werner Zac, 'The Black Panthers advocated armed struggle. Emory Douglas' weapon of choice? The pen', 28 March 2007, http://www.sfgate.com/entertainment/article/ The-Black-Panthers-advocated-armed- struggle-2568057.php; access date August 2012.

23. Ward Churchill, Jim Vander Wall, *Agents of Repression: The FBI's Secret Wars Against the Black Panther Party and the American Indian Movement* (Cambridge, MA., 2002), p.42.

24. Jay Clarke, 'The Politics of Geography and Process: Impressions from South Africa, 1965 to Now' in *Art in Print* (September–October 2011), vol.1, no.3, see http://artinprint.org/index.php/exhibitions/ article/the_politics_of_geography_and_process; access date May 2012.

25. Quoted in Jane M. Farmer et al, *Crossing Over/ Changing Places*, exh. cat., Pyramid Atlantic, Riverdale, MD., 1992, p.145.

26. 'Conversation: The Art of Identity with Sonia Boyce and Manthia Diawara', *Transition* (1992), no.55, pp.194–5.

27. Jacqueline Brody, 'Every action is political and spiritual: an interview with Willie Cole', 14 February 1997, www.artnet.com; access date 1 August 2012.

28. *The Apple of Adam's Eye*, Philadelphia Fabric Workshop, Philadelphia, PA., 1993.

29. Quoted in *Atta Kwami*, exh. cat., Beardsmore Gallery, London, 1995.

30. Quoted in Jerry Saltz, 'Post-Black', *Village Voice*, 15 May 2001.

31. Quoted in David A. Bailey, 'Aspects of the Liberal Dilemma', *frieze* (September-October 1991), issue 1.

32. http://www.adrianpiper.com/dear_editor.shtml; access date 1 August 2012.

33. Chris Ofili, *Guardian* video interview, 3 February 2010.

34. Quoted in Gaby Wood, 'The return of Zadie Smith', *Telegraph Magazine*, 25 August 2012.

35. Interview with Zoe Whitley, 2 October 2012.

36. Quoted in Jessica Morgan (ed.), *Ellen Gallagher*, exh. cat., ICA, Boston, MA., 2001, p.18.

37. Quoted in Laylah Ali, *Typology* (Pennsylvania, PA., 2007), p.19.

38. Quoted in Hilarie M. Sheets, 'Photographer and Subject are One', *New York Times*, 12 September 2012.

39. Lubaina Himid, 'A Fashionable Marriage' in *The Other Hogarth: Aesthetics of Difference*, Bernadette Fort and Angela Rosenthal (eds) (Princeton, NJ., 2001), p.271.

40. Himid (cited note 39), p.274.

41. Carol Vogel, 'The Inside Story of Outsiderness', *New York Times*, 24 February 2011.

42. Tyler Coburn, 'Glenn Ligon: I Am …' *Art Review* (January–February 2009), issue no.29, p.59.

43. Jason Moran, 'Glenn Ligon', *Interview Magazine*, 21 July 2012, http://www.interviewmagazine.com/ art/glenn-ligon/#; access date 9 August 2012.

44. Interview with Zoe Whitley, 28 June 2012.

45. Trenton Doyle Hancock, 'Tunnel', essay for *New Prints 2011/Summer*, exh. cat., IPCNY, New York, NY, 2011, selected by Trenton Doyle Hancock, http://www.ipcny.org/files/NP11_Summer%20 brochure%20draft.pdf; access date September 2012.

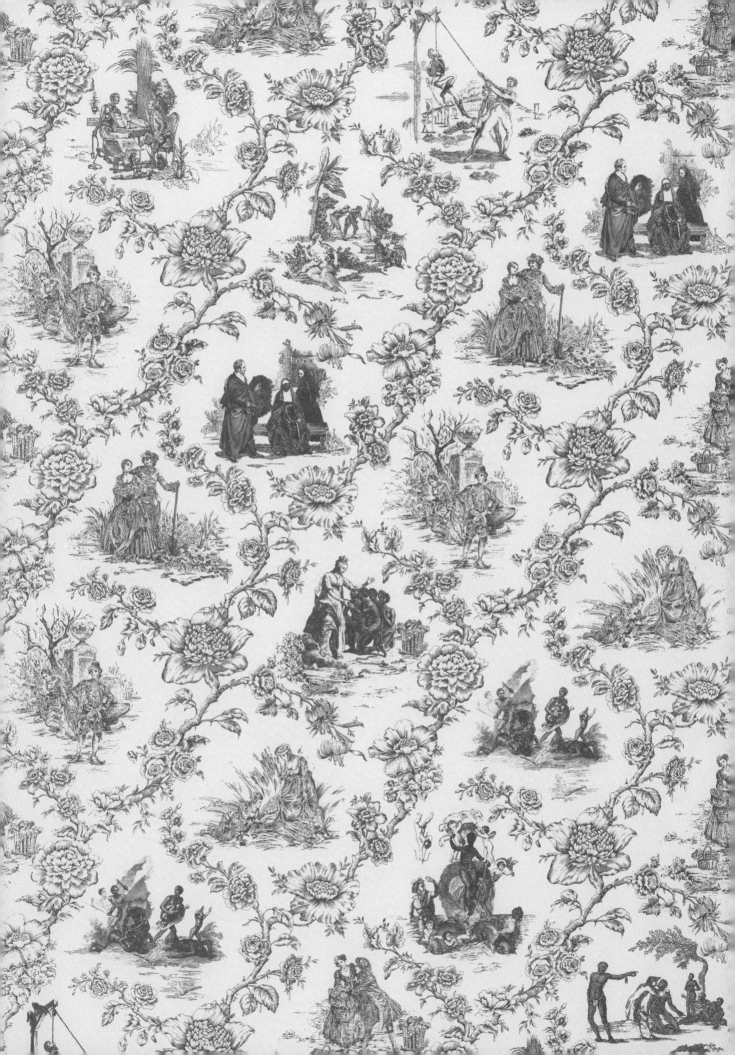

PLACE

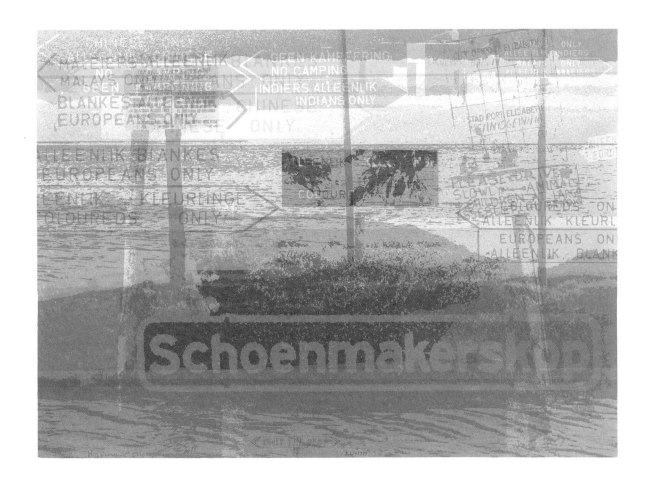

Nils Burwitz (born 1940)

Only the Best, 1976

Colour screen print; 10/30 | 72.7 × 100.3 cm | v&a. e.1418 1983 | Given by the artist

Born in what is now Poland, Nils Burwitz moved first to West Germany and then, in 1958, to South Africa. Here he was profoundly affected by the racial discrimination that had been institutionalized by the country's apartheid laws. His prints (see also pp.46 and 113), which employ photographic imagery mediated through a subtle use of silk screen, exploiting its capacity for layering, encapsulated his response to what he saw: 'a new form of protest art'.[1] He focused on the absurdities of apartheid's rules, and their physical manifestation in the form of notices and signs that policed public spaces. The predominant sign here is for Schoenmakerskop, a beach near Port Elizabeth. Clustered around it, layered over it and over one another, like palimpsests, are a multitude of injunctions in English and Afrikaans, such as No Camping; Indians Only; Chinese Only; Europeans Only. A babel of codified discrimination, repeated so often that it becomes just another feature of the landscape – but one which despoils a paradise. In capturing this visual cacophony Burwitz exploits to the full the screen print's capacity for layering, and for multiple applications of translucent inks.

1. Edward Lucie-Smith in Nils Burwitz, *Auf dem Hochseil/ Walking the Tightrope* (Wolfenbütel, Germany, 2002), p.28.

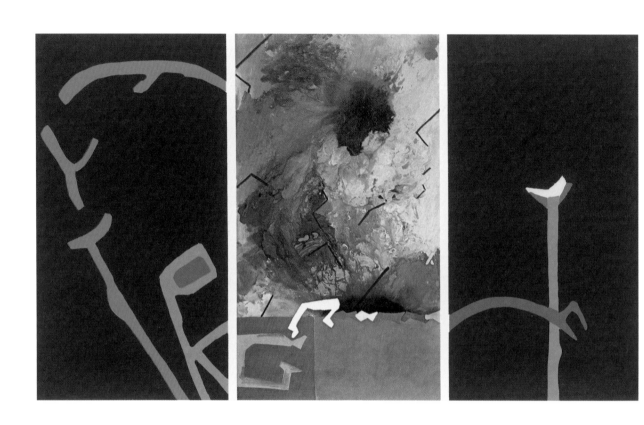

Winston Branch (born 1947)

Ju-Ju Bird, 1976

Colour screen print; 56/150 | 58.4 × 98.3 cm | V&A: E.1400–1976

Citing Impressionism generally, and Claude Monet's *Water-lilies* series specifically, as a formative but indirect influence, followed by the vibrant and expressive use of colour found in works by Henri Matisse and Nicholas de Stael, St Lucia-born Winston Branch developed his own symbolic language to express an internal landscape based on instinct and intuition. In an artist's statement titled *From Figuration to Abstraction* (1994), for an exhibition in Dominica organized by Alliance Française de Roseau, Branch revealed, 'as I have found my identity as an artist, it was inevitable that this would lead to pure abstraction. It is cutting at the edge of the bone of the human experience as the faculty of the imagination is the highest order of the manifestation of one's soul.'

Branch trained as an artist in Britain at the Slade School of Fine Art and later taught there and at other London art colleges. This work, however, was created while Branch was in Berlin, where he spent the years 1975–6. *Ju-Ju Bird,* while a single printed composition, has three distinct sections and is presented as a triptych. In many ways it encapsulates Branch's various artistic influences and his own synthesis of them, the Matisse-like motifs of solid colour and blocky line on black flanking a more riotous light-filled burst. The title may be construed as a sly reflection on the way British people viewed African or black artists and their work at the time – ever quick to interpret a composition, however abstract or conceptual, as inherently linked to an assumed exotic or esoteric cultural root.

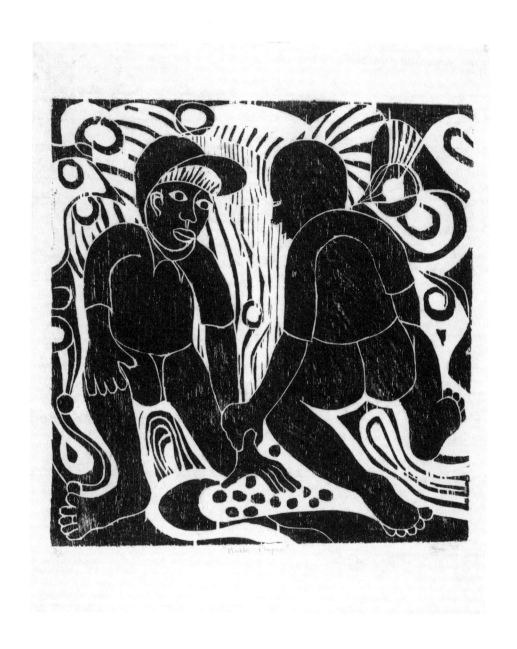

Paul Sibisi (born 1948)

Marble Players, 1983

Woodcut; 3/25 | 64.9 × 53.8 cm | V&A: E.634–1985

Paul Sibisi was born in Cato Manor, a working-class area of Durban, South Africa, popularly known as Umkhumbane. Under the apartheid regime Umkhumbane became famous for the residents' acts of defiance and resistance. Sibisi's artistic talents were first noticed when he was training to become a teacher, and he was awarded a bursary to specialize in art teaching at the Ndaleni Art Training School. He later studied at the influential Rorke's Drift ELC Arts and Crafts Centre, which has fostered the printmaking skills of so many artists in South Africa. Working mostly with woodcut and linocut, Sibisi depicts subjects drawn from everyday urban life. In much of his work there is a direct political message, but sometimes references to conflict and protest are merely hinted at by means of gaze and gesture. Here, the player on the left stares coldly at his opponent as he grips his wrist, suggestive of latent aggression and suppressed violence.

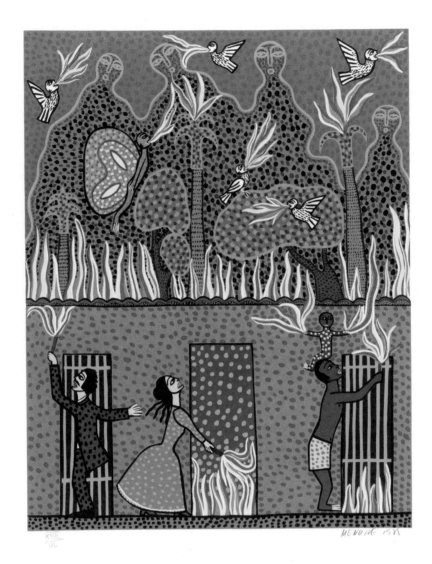

Manuel Mendive (born 1944)

Quema de Bayamo (The Burning of Bayamo), 1985

Colour screen print; XVIII/UL | 69 × 60 cm | V&A: E.1240–1995

This arresting scene, printed in vivid colours, was made three years after Cuban painter Manuel Mendive's first trip to West Africa. His singular style incorporates both African and Western traditions, just as the Afro-Cuban religion of Santeria brings together the Roman Catholicism of Spanish plantation owners and the West African traditions of plantation slaves, particularly those of the Yoruba culture in present-day Nigeria and Benin. This cultural fusion is a recurrent theme in Mendive's work.

Compositionally, the print draws heavily upon traditional Dahomey hangings, with black or gold backgrounds, appliquéd with brightly coloured pieces of cloth assembled to memorialize triumphant scenes from historical events. *Quema de Bayamo* re-imagines the sacrifice made on 12 January 1869 by Cuban rebels, who chose to burn their sugarcane-rich town of Bayamo, a stronghold populated by freed slaves and anti-colonial revolutionaries, rather than cede it to the Spanish army. Considered a defining moment in Cuban history and one that shaped the indomitable spirit of the island, this print commemorates the rebellion, with white and black Cubans united in an act of supreme defiance.

The black smoke rising above the flames outlines the forms of four spirit figures presiding above the scene and engulfing the surrounding foliage. Inspired by Orishas – spiritual intercessors between Nature and Humanity – and the raw power of nature, the image calls to mind Shango, the fire deity, who is invoked as a source of vengeance and justice.

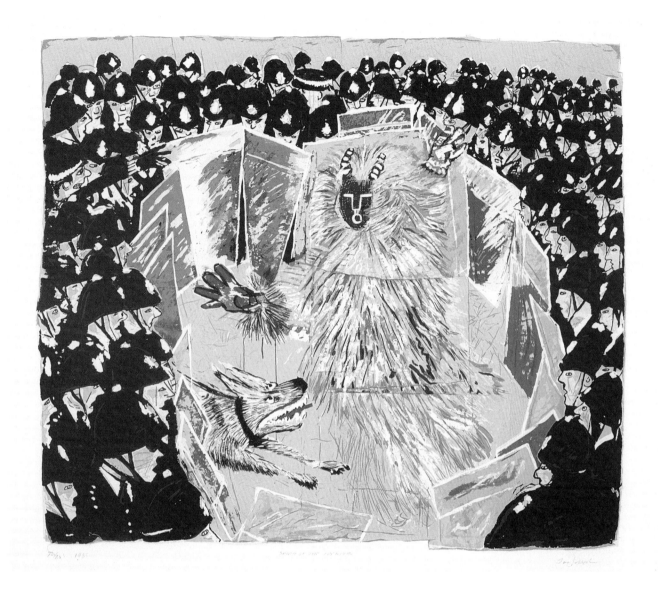

Tam Joseph (born 1947)

Spirit of the Carnival, 1988

From the *Jouvert* portfolio | Published by Paddington Printshop, London
Colour screen print; 72/86 | 76 × 113 cm | V&A: E.1233–1995

Born in Dominica, Tam Joseph came to London as a child. This print – based on his 1984 painting of the same title – was commissioned by John Phillips of Paddington Printshop for a portfolio of screen prints (with contributions by 50 artists) entitled *Jouvert*, designed to celebrate — Carnival. His title is deliberately ironic – the character of the annual carnival in Notting Hill (west London) had by this date become tainted by associations with criminality. Once a simple celebration of Afro-Caribbean culture inspired by the street parties, carnivals and masquerades traditional to islands in the Caribbean, the London event was increasingly the occasion of confrontation between the police and the black community, the media highlighting instances of violence, robbery and drug-dealing, as well as larger public order issues.

Here Joseph shows a series of oppositions played out between the solitary dancer and the massed ranks of the policemen who threaten to engulf him. As the vibrant focus of the composition, the central figure is an exuberant explosion of colour and energy surrounded by the blank-faced uniformity of the black-uniformed policemen. Individuality confronts conformity, anarchy challenges authority, celebration is threatened with oppression. The masquerader's raffia costume and 'African' mask mark him as definitively 'other', his black face contrasted with the white faces turned towards him, as he is corralled by the shard-like riot shields which pen him in but also frame an arena for his performance.

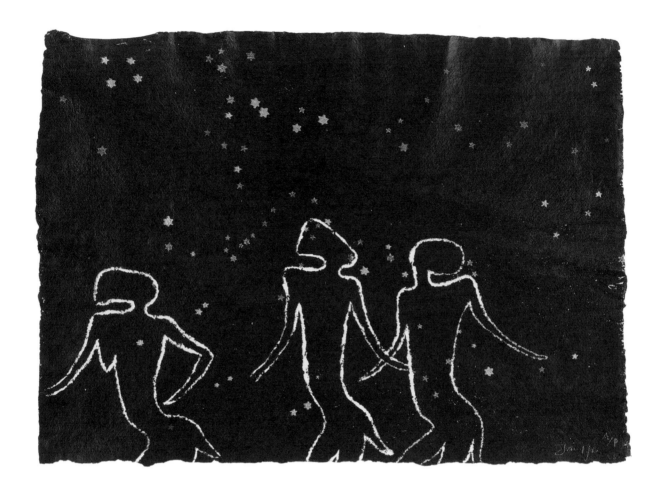

Gavin P. Jantjes (born 1948)

Zulu, the Sky Above your Head, 1988

From the *Jouvert* portfolio | Published by Paddington Printshop, London
Colour screen print on handmade paper; artist's proof | 39.5 × 56.5 cm | V&A: E.1232–1995

In his work the painter and printmaker Gavin Jantjes has often commented on the politics of his native South Africa, sometimes directly (see p.112), sometimes obliquely. As with Tam Joseph's work (see p.35) this screen print was commissioned for *Jouvert*, the portfolio published by Paddington Printshop. It relates to a painting, and Jantjes has given it an enhanced physical quality by using handmade Indian khadi paper and overprinting in different shades of blue to create a richly textured surface. The title derives from the English translation of the word 'zulu' as 'the space above your head' or 'the heavens'. The image alludes to the Khoi San myth concerning the creation of the Milky Way, in which a young girl reaches into the fire and throws a handful of burning embers into the sky. The coals form the stars, and the white ashes become the Milky Way. The figures here are drawn in outline in the style of the rock paintings and carvings of the Khoi San, the indigenous peoples of southern Africa. Jantjes has described the significance of such subjects for him: 'The heavens are the most neutral space – no nations lay claim to the heavens. They are undefined … and accessible to every human being.'[1]

1. Quoted at http://africa.si.edu/exhibits/insights/jantjes-artist.html; access date May 2012.

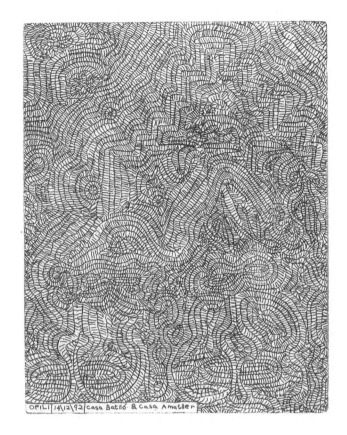

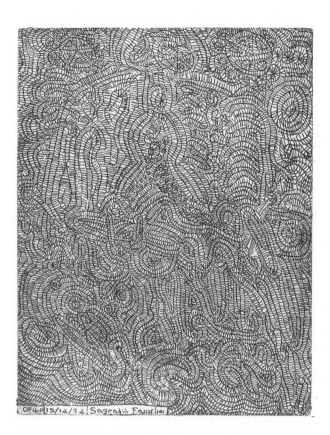

Chris Ofili (born 1968)

From T to B with L, 1992

Suite of 10 etchings | Each 38.3 × 29 cm | V&A: E.679-88–1993

Rhapsodic, lyrical draughtsmanship has become a defining feature of Chris Ofili's *oeuvre. From T to B with L* is a series produced in, and inspired by, the city of Barcelona, Spain. While Ofili is reluctant to divulge the series title's full significance, it suggests the pathways of journeys taken and the points in between, also calling to mind correspondence sent (with love?) along the way. In 1992, while still studying at the Royal College of Art (1991–3), Ofili travelled around Barcelona with copper etching plates, positioning himself in a different part of the city each day to execute an original work, in the process creating his first ever series of prints. In the same year, he completed his first trip to Africa, having been awarded a travel grant to Zimbabwe where he attended the Pachipamwe International Artists' workshop, held annually from 1988 to 1994.

Always resistant to lazy, culturally specific interpretations of his own work, Ofili has steadfastly debunked the notion of the trip being a search for his 'roots'. Rather it provided him with new and rich references from which to build a multi-layered aesthetic of his own devising. On seeing the cave paintings in the Matapos Hills, Ofili was struck by the repeated, hatched mark-making arising from the artists' semi-hallucinatory state, induced by drum rhythms. He tested himself in a not unrelated way in the streets of Barcelona, with hours of tiny mark-making on a single, grounded etching

plate, not looking up from the plate until he considered it completed.[1] Ofili has spoken of the sensory heightening that comes from being in unfamiliar surroundings; how it alters visual awareness and changes one's perceptions.[2]

While Ofili is now known primarily as a painter, the flexibility of printmaking in general and the portability of the etching plate in particular enabled him to develop a process that would have proved impractical with easel and canvas. These prints reward those who intently study them: the various landmarks designated by the etchings' respective titles slowly begin to emerge from the page. Ofili reverses the exoticizing gaze that artists historically brought to bear when capturing foreign landscapes. European artists such as Royal Academicians John Frederick Lewis and David Roberts, known as 'Orientalists', depicted scenes of nineteenth-century Spain and North Africa with a heightened sense of mystery and sensuality. Here, the serpentine hatch marks are disconcerting rather than way-finding, dissolving a city renowned for its art and architecture into patterns previously unseen.

1. 'Changing locations heightens visual awareness; suddenly everything has different values', from Peter Doig and Chris Ofili interview, *BOMB* (Fall 2007), issue 101.
2. Rosie Miles, from conversation with the artist, 1992.

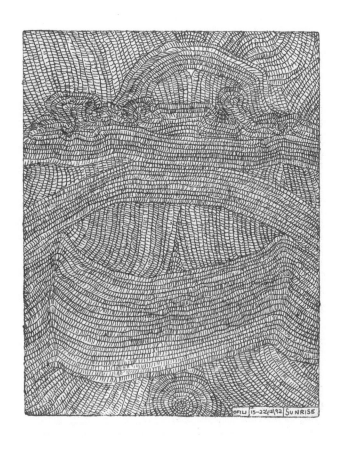

OFILI 15-22|12|92 SUNRISE

OFILI 15|12|92 VIEW FROM TOP SAGRADA FAMILIA

OFILI 16|12|92 TIBIDABO

OFILI 17|12|92
PLAÇA DE L'ESCORXA

OFILI 18\12\92 GÜELL PARK

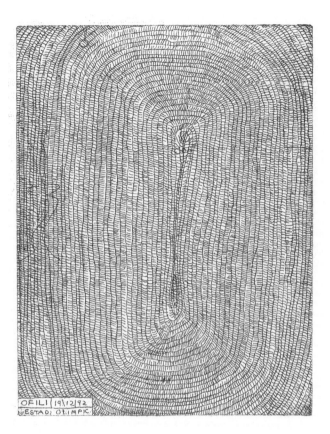

OFILI 19\12\92 ESTADI OLIMPIC

OFILI 19-20\12\92 BARRIO CHINO

OFILI 21/12/92 TURKEYS

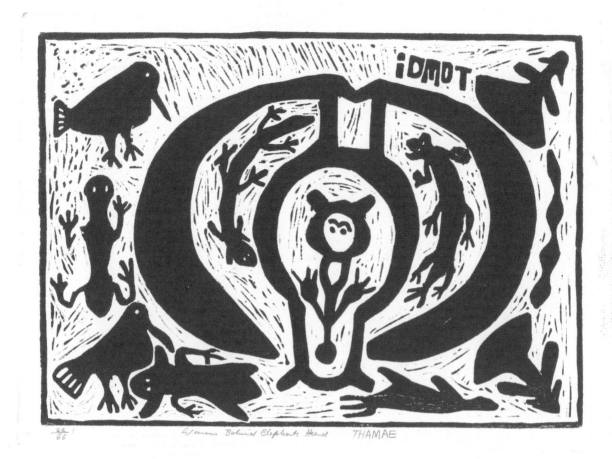

Thamae Setshogo (about 1970–2004)

Womans Behind Elephants Head, 1993

Linocut; 22/66 | 26.5 × 35.5 cm | V&A: E.728–1993

Thamae Setshogo, one of Botswana's best-known artists, established an international reputation through his involvement in the Kuru Art Project (see introduction, p.13), a scheme that enables San artists in the Kalahari region to benefit financially from their artistic skills. Printmaking is not a craft indigenous to the region, but artists are taught simple processes, such as linocut, which allows them to translate the kinds of imagery traditionally applied to ceramics and leatherwork into conventional pictorial formats. Setshogo worked as a painter and as a woodcarver, but his bold graphic style found its most effective expression in the immediacy of linocut. His work –

like much of that produced through Kuru – has a clear affinity with San rock painting in which there is no recessive pictorial space, only motifs floating together on the surface. As here, he generally focused on the natural world – birds, animals, insects and plants, often simplified almost to the point of abstraction and pattern. Indeed, his punning title here highlights the ambiguity of the motifs depicted. These are nostalgic subjects characteristic of the society in which he lived, never explicitly political but simply celebrating and commemorating a disappearing way of life.

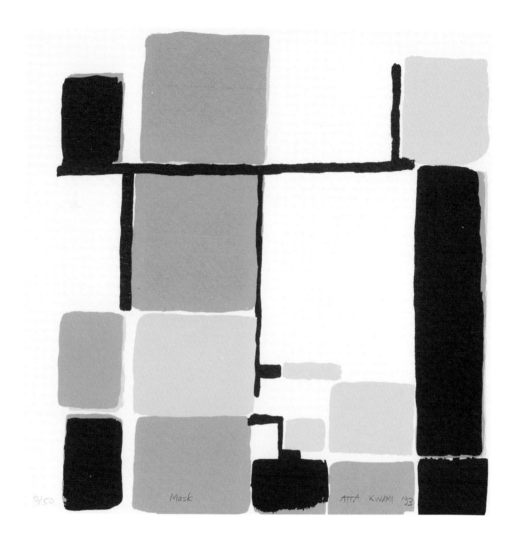

Atta Kwami (born 1956)

Mask, 1993

Published in the Royal College of Art Printmaking portfolio, 1993 | Colour screen print; 9/50 | 27.9 × 27.9 cm
V&A: E.615:23–1996 | Given by the Royal College of Art

Atta Kwami was born in Accra, Ghana, where his mother was a well-known artist and arts educator, and his father a musician. He studied painting at the College of Art at Kwame Nkrumah University of Science and Technology (KNUST), followed by a period of teaching in Nigeria, and then returned to KNUST as lecturer in painting and printmaking. He now works independently in Ghana and Britain. This print was made when he was studying for a diploma at the Royal College of Art, London.

Kwami's abstract style has been compared to the patterning of textiles made by the local Ashanti and Ewe peoples; others have suggested that it is the visual rhythms of life in the streets that are echoed in his work: 'the kiosks, lockup shop fronts, corrugated roofs, stacked crates, wooden scaffolding, workshops, market stalls, taxi queues, timber trucks, iron

gates …'[1] He has acknowledged these inspirations, adding, 'The qualities I seek in my work are clarity, simplicity, intensity, subtlety, architectonic structure, musicality (rhythm and tone), wholeness and spontaneity … I have focused on colour as subject matter.'[2]

1. Pamela Clarkson (1998), quoted in *Atta Kwami: An Artist's Sense of Place: The World of Atta Kwami,* exhibition press release, Nicolas Krupp Contemporary Art, Basel, 2011.
2. Quoted in *As It Is! Contemporary Art from Africa and the Diaspora,* December 2010–March 2011; http://www.themojogallery.com/asitis/artist-atta-kwami.php; access date 26 September 2012.

Louis Khehla Maqhubela (born 1939)

Untitled, 1994

Etching and colour oil pigment on paper | 39 × 58.5 cm | V&A: E.2317–1997

Born in Durban to Xhosa parents, Louis Maqhubela moved to Johannesburg in 1952, where he studied at the Polly Street Art Centre, and later worked as a commercial artist, designing record covers. As with other South African artists of his generation, Maqhubela's early reputation and subsequent international success were founded largely on his ability to present recognizably African subject matter (such as the so-called 'Township' pictures of shanty-town street life), employing stylistic mannerisms derived from the European avant-garde. Later his work developed in the direction of pure abstraction, but often retained vestiges of figuration, as seen here in the sketchy figures and landscape motifs that demonstrate the influence of Paul Klee. Maqhubela's work has never been explicitly political, yet the apartheid regime would not allow him to build his own studio (hence in 1973 he moved to Spain and then in 1976 to Britain). But as he has recently written, 'Even abstract art by a black practitioner was a declaration of war against being stereotyped, bearing in mind that abstraction has, for centuries, always been Africa's premier form of expression. Why would our ancestral form of expression suddenly be deemed "foreign" to the black man of the twentieth century?'[1]

1. See Marilyn Martin, *A Vigil of Departure – Louis Khehla Maqhubela* (Johannesburg, 2010), p.16.

42

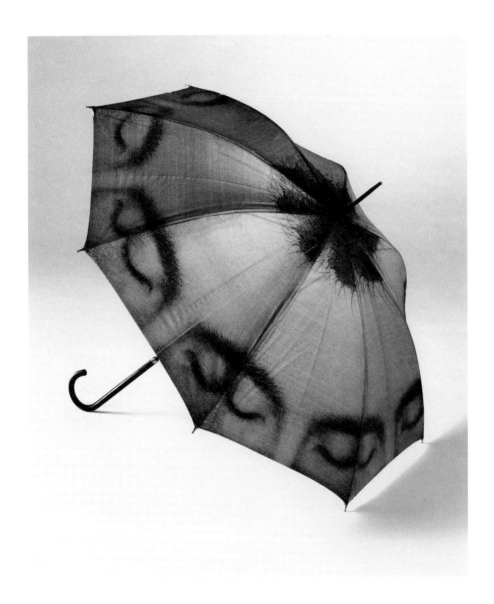

Sonia Boyce (born 1962)

Umbrella for *Portable Fabric Shelters*, 1995

Screen print on rubberized fabric attached to umbrella frame; 16/22 | Diameter when open (excluding finials) 86.5 cm
V&A: E.21–2006 | Purchased through the Julie and Robert Breckman Print Fund

In 1994 the London Printworks Trust, a workshop and studio that specializes in facilities for printing on fabric, commissioned a group of artists to make work for an exhibition called *Portable Fabric Shelters*. The theme was global migration, and focused on the situation of refugees and the homeless. Sonia Boyce made a group of works, including blankets, a tent and this umbrella, itself a kind of temporary shelter. Around the edge of the umbrella she screen-printed an enlarged photographic image of the brows and closed lids of a pair of eyes. Boyce has spoken about the ways in which we might get inside someone else's head, in the sense of really understanding their point of view and experience. Sheltering beneath an umbrella on a crowded street is a means of not only taking cover from the elements but also keeping yourself separate from those around you – and seen from outside, the closed lids refuse a connection, excluding the viewer. On the other hand, inviting someone else to share your umbrella creates a temporary intimacy, and a shared perspective.

HISTORY

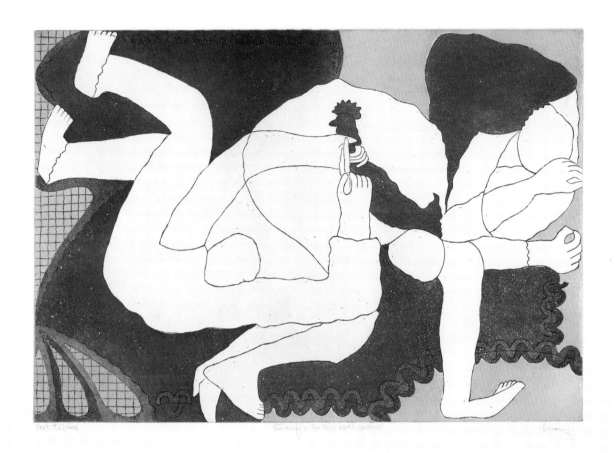

Uzo Egonu (1931–1996)

Sacrifice to the Earth Goddess, 1974

Colour etching and aquatint; artist's proof | 58.5 × 77.5 cm | V&A: E.951–1977

Born in the city of Onitsha, Nigeria, Uzo Egonu was sent to Britain for his education at the age of 13. He established himself in London and visited Nigeria only once more before he died. In the 1950s he studied at Camberwell School of Arts and Crafts and at St Martin's School of Art. His work – in painting and in print – reflects both this Western training and his enduring attachment to his Igbo heritage, and combines formal traits derived from European modernism with African motifs. Here three figures are seen from above; one holds a knife to the neck of a cockerel. This enactment of sacrifice is surely a reference to Igbo religious practices, but the bold outline drawing of the figures and the background palette of blue and yellow suggest the influence of Matisse.

Nils Burwitz (born 1940)

Revolving Door I and *II*, from the suite *Heads or Tails?*, 1982

Printed by Advanced Graphics, London | Colour screen print (single sheet printed both sides); 9/50 | 84.2 × 70.6 cm | V&A: E.1433–1983

In a number of his prints Nils Burwitz focuses on the signs that policed public life under apartheid. The inhumanity of bureaucratic language and the inherent discrimination embedded in the terminology is as chilling as any more graphic abuse of human rights. As in *Namibia: Heads or Tails?* (see p.113), Burwitz makes effective use of a double-sided print, and of layering, transparency and reflection.

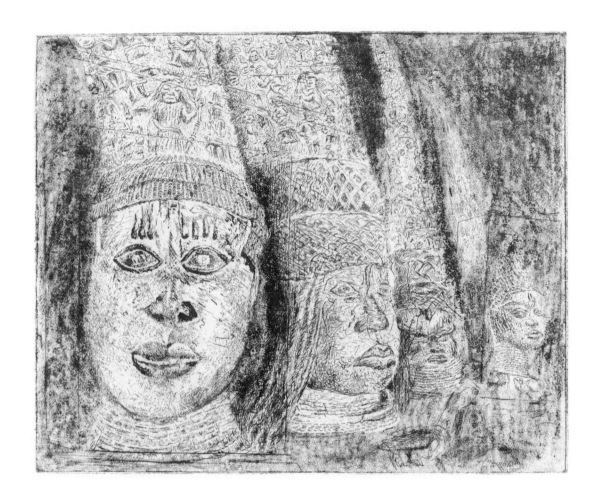

Tony Phillips (born 1952)

The History of the Benin Bronzes I–XII, 1984

Colour etchings; edition numbers various, each one of 12 | 21.4 × 26.5 cm | V&A: E.48-59–1987

Tony Phillips's sequence of etchings is his narrative of the brutal conquest and looting inflicted by the British as part of their imperial enterprise in Africa. In 1896 the British Consul in Lagos attempted to enter neighbouring Benin City during a religious festival, hoping to negotiate an end to the ruler's monopoly on the trade in palm oil and other commodities. Although envoys from the Oba (king) had previously protested at the timing of such a visit by foreigners, the Consul proceeded, and his unarmed party were ambushed and killed. Retribution came in March 1897 when a punitive raid on Benin City deposed the Oba and sent him into exile. British rule was imposed, and the city ransacked; a wealth of accumulated art works – carved ivories, brass plaques and cast bronze sculptures – were seized and sent back to Europe, where they were dispersed at auction to museums in Berlin and London, and to private collections. The British press sought to justify this brutality by depicting the Oba and his people as 'savages' who practised human sacrifice, but in fact, as the magnificent bronzes demonstrate, Benin was a sophisticated and technologically advanced society.

Phillips's caustic narrative shows us the crucial role of the bronzes in the rituals and ceremonies of the civilization that produced them, recounts the raid and the looting in its aftermath, and then follows the sculptures to Europe. Here they pass through the auction houses and are assimilated into the scholarly apparatus of the art world (afforded the rare status of 'works of art' from an otherwise 'primitive' continent). Finally they come to rest in the sterile isolation of museum display cases and the living rooms of rich collectors. The museum visitors are depicted as vapid insubstantial caricatures, contrasted with the eloquent individualized bronze heads at which they gaze without understanding. Like living creatures caged for public entertainment, the heads look out at us in mute appeal, dislocated and diminished in their captivity. Phillips makes subtle but effective use of the etching medium and the careful choice of coloured inks; at the start of the narrative, set in Africa, he employs warm brown tones, but these gradually mutate to cold, bluish-blacks for the later scenes in the West. The symbolism is muted but clear. For Phillips (himself of Nigerian ancestry), the history of the Benin bronzes is a powerful metaphor for the deracination that has been the fate of so many African peoples and their cultures. It is also a plangent argument for their repatriation.

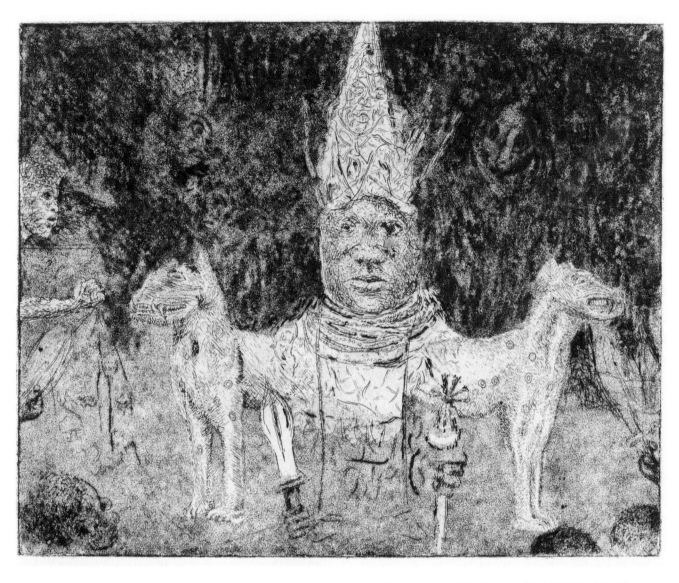

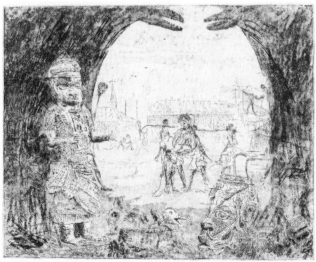

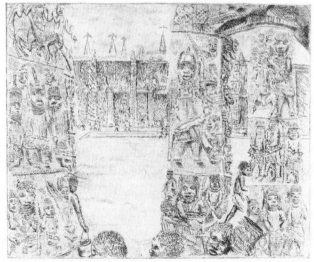

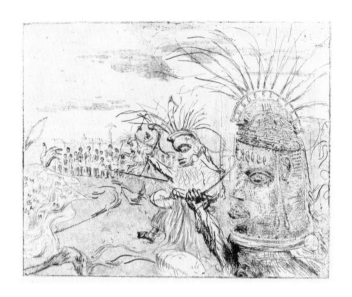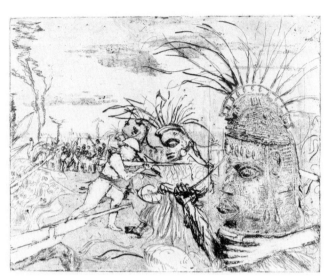
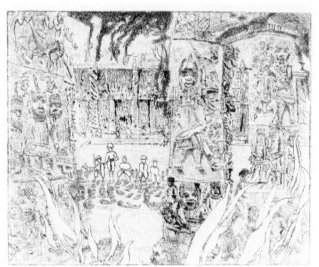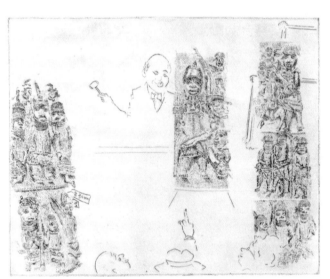

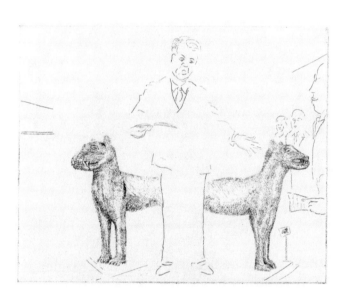 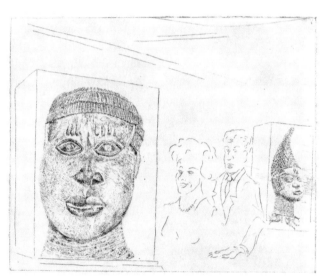

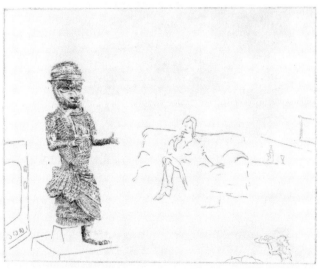 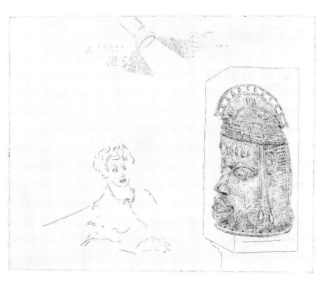

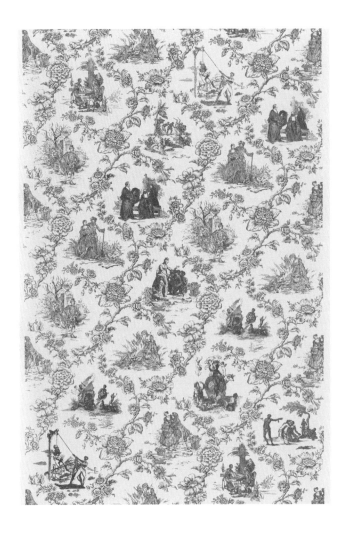

Renée Green (born 1959)

Commemorative Toile, 1992

Screen print in red on paper-backed cotton sateen | 457.5 × 144.2 cm | V&A: E.2320–1997

Using the visual language of domestic decoration Renée Green explores the ways in which beliefs, behaviours and perceptions are woven into the fabric of daily life. This toile was originally produced for an installation of soft furnishings, wall covering and even costume for the gallery owner. Using pattern, with its predictable structure of order and repetition, she represents familiar ideas and received wisdom, but by incorporating imagery that is apparently 'out of context' she disrupts expectations and comfortable assumptions.

At first sight *Commemorative Toile* appears to be a direct reproduction of the eighteenth-century, copper-plate-printed cotton textiles known as toiles de Jouy (named after the French town where they were first produced). Green's design conforms to the characteristic decorative style of such textiles, but she also references those with patterns inspired by historical events, including war and revolution. Here, among the conventional bucolic scenes,

are discordant images copied from eighteenth- and nineteenth-century engravings. In one vignette a Haitian revolutionary lynches a white French soldier, and another shows the Senegalese heroine of the novel *Ourika* (1823); other scenes include a slave market and illustrations to texts recording the abolition of slavery.

Green here suggests that those artefacts which have survived into the present – and especially those preserved and displayed in museums and thus given special status as historical evidence – show us only one highly selective version of history, focused on white wealth and success, much of which was built on black – and in particular black slave – labour. But she also resists a simplistic revisionist view of history by choosing imagery that reminds us that Africans in the eighteenth century were not simply victims or chattels; many were educated, independent and fully capable of self-determination.

Tayo Quaye (born 1954)

The Man, 1995

Colour linocut on Japanese paper; 6/7 | 96.7 × 208.5 cm | V&A: E.455–1999

Tayo Quaye is a painter and a printmaker, best-known internationally for his imposing large-scale linocuts. He trained at the Yaba School of Technology, Lagos, followed by a two-year apprenticeship with the artist Bruce Onobrakpeya.

Quaye's work exemplifies the productive synthesis of Eurocentric art school teaching (established in Nigeria in the 1940s) with the revival of indigenous art traditions, forms and ideas. This is a rich and complex print; it brings together allusions to iconic figures from Western art history – the Virgin and Child, Leonardo's Vitruvian Man, the radiant man in William Blake's *Glad Day*, Rodin's *The Thinker* – but styled and posed as befits an African context, with a distinctively African use of pattern and motifs drawn from African fauna. In its emphasis on line, in the integration of the figures with a densely patterned ground, and in the subtly modulated application of colour, this linocut is a masterpiece of ambitious and accomplished printmaking.

Faith Ringgold (born 1930)

Sunflower Quilting Bee at Arles, 1996

Colour lithograph; printer's proof | 57.3 × 76.3 cm | v&a: e.879–2003 | Purchased through the Julie and Robert Breckman Print Fund

Faith Ringgold, artist and social activist, came to prominence for innovating 'story quilts' as her primary means of artistic expression. Combining the African-American craft tradition of quilting and the oral history of storytelling, she creates large-scale painted canvases as a means of re-asserting a black presence into both American history and the history of art. Trained as a painter in the 1960s, Ringgold was influenced by the contemporary social criticism of writers Amiri Baraka (formerly Everett Le Roi Jones) and James Baldwin, detailing the black experience in America. Textiles entered her work from the 1970s, when she began collaborating with her mother Willi Posey Jones, a Harlem fashion designer, on soft sculpture dolls and masks, as well as making her first forays into incorporating quilted strips onto canvas.

Awarded La Napoule Art Foundation's prestigious residency in 1990, Ringgold spent some time in France before returning to the United States. In the same year she completed a silk-screen edition based on an earlier story quilt series *Tar Beach 2* at the Fabric Workshop in Philadelphia.

This print is based on a 1991 story quilt, painted in acrylic on canvas with a tie-dyed, pieced fabric border. It is the fourth in a twelve-part series of works called *The French Collection* (1990–7). The artist's alter ego Willia

Marie Simone – named in part as a tribute to her late mother – lives through a thrilling re-imagining of African-American history and French modernism as an artist, muse and mother.

Set in a field of sunflowers in Arles, this six-colour lithograph shows an illustrious and extraordinary gathering of nineteenth- and twentieth-century women, taking part in a quilting bee. Willia Marie Simone (at lower left, fittingly with yellow flowers in her hair and on her dress) is joined by – from left to right – entrepreneur Madam C. J. Walker, the first African-American millionaire; abolitionist and women's rights activist Sojourner Truth; journalist, suffragist and anti-lynching advocate Ida B. Wells; Civil Rights leader Fannie Lou Hammer; humanitarian and abolitionist Harriet Tubman; Civil Rights leader Rosa Parks; educator and activist Mary McLeod Bethune; and human rights activist Ella Baker.

Ringgold questions the place of black women in culture and society, and repositions them firmly in the foreground, in the process relegating to the sidelines one of art history's heretofore best-known and most beloved male artists, Vincent Van Gogh. The central quilt, dominated mostly by a palette shared with the red, black and green of the Pan-African flag, becomes a locus for female creativity and solidarity.

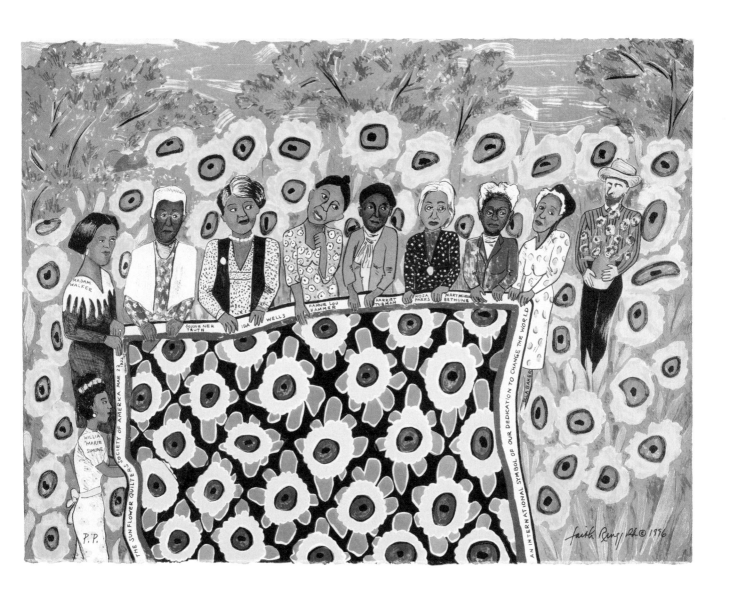

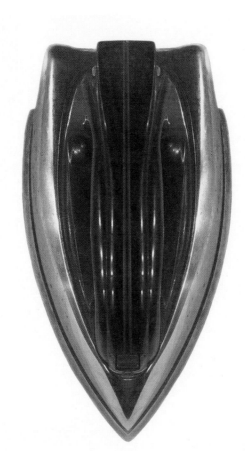

Willie Cole (born 1955)

Loyal and Dependable, 2002

Printed by Quality House Graphics, New York | Colour Iris print; 9/12 | 120 × 89 cm
V&A: E.3580–2004 | Purchased through the Julie and Robert Breckman Print Fund

'I work obsessively with a single object in multiples and turn it into other things.'[1] This print was produced in collaboration with Hugo Espinosa at an industrial printing house in New York called Quality House Graphics, under the aegis of the Brodsky Center for Innovative Editions at Rutgers, the State University of New Jersey. Willie Cole uses domestic and commonplace objects to create both sculpture and graphic work; the latter came to prominence through his innovative use of the steam iron. The technique he used was closely aligned to relief printing, using the metal plate of the iron as a stamp. In reality, it is most like a branding iron: Cole allows the iron to scorch various surfaces, such as canvas or paper, so that it appears scorched, but the effect is actually achieved digitally for the series of prints.

Cole was to experiment further with digital media, but the allusions are similar. Slaves were frequently branded as a sign of ownership, reducing vulnerable human beings to the status of cattle. Where the scorch is totemic, evidence of both power exerted upon others and of inner strength, Cole's manipulated photographic images (this work is one of many 'iron' prints), together with their titles, give rise to searing messages. The titles refer to actual advertising copy used to promote a given iron's performance features while simultaneously providing a stinging reminder that African people, sold as slaves, were described using the same dehumanizing 'performance'-based terminology. Cole's titles equally pay homage to the devotion and tirelessness of black women in the domestic employ of white families and businesses; women who sacrificed time spent with their own families and in their own households to earn a living.

The result is striking both in its familiarity as an easily recognizable domestic item and as a symbol that evokes both the formal qualities of African masks and the indelible survival of African ancestry. 'My work moves along a couple of lines. I focus on spirituality. And I try to combine that with the everyday existence. I think that everything is one thing. So my art is really the expression of the oneness – how one thing is everything and everything is one thing.'

1. All quotes taken from Boston University, Contemporary Perspectives Lecture Series. Hosted by College of Fine Arts, School of Visual Arts, 6 November 2006.

William Kentridge (born 1955)

Untitled (Chairs) from *Zeno Writing II*, 2002

Photogravure, etching and drypoint; 23/30 | 50.4 × 65.5 cm | V&A: E.133–2005 | Purchased through the Julie and Robert Breckman Print Fund

The work of William Kentridge has always been rooted in his opposition to the apartheid regime and its legacy in his native South Africa. This print comes from a suite based on the novel *Confessions of Zeno* (1923) by Italo Svevo, the imagery overlaid with looping abstract calligraphy, like a visual stream of consciousness. The novel centres on a middle-class businessman in Trieste shortly before the First World War, as he recalls the moments of indecision and irresolution that have shaped his life, and coloured his familial relationships. Written as if from the psychiatrist's couch, it conveys the hero's weakness and guilt, and the limitations of his self-knowledge. It is this idea of guilt, and of impotence despite self-knowledge, that Kentridge has explored repeatedly as he confronts the implications, for individuals and societies, of their responses to political events. Motifs from the prints appear again in the film *Confessions of Zeno*, which Kentridge made with the Handspring Puppet Company in Cape Town, featuring life-size puppets, animation, live actors and archive footage. He has written, 'When I first read [Svevo's novel] some 20 years ago, one of the things that drew me to it was the evocation of Trieste as a rather desperate provincial city at the edge of an empire – away from the centre, the real world. This felt very similar to Johannesburg in the 1970s. In the years following this has persisted. And caused me to return to the book.'[1]

1. Quoted in Sophie Perryer, 'Kentridge's Confessions tops the bill at Grahamstown', in *Artthrob* (June 2002), no.58. See http://www.artthrob. co.za/02jun/news/gtown.html; access date May 2012.

Isaac Julien (born 1960)

Untitled (*Déjà-vu no.2, Baltimore* series), 2006–7

From the Rivington Place portfolio | Printed by Randy Hemminghaus
Published by the Brodsky Center for Innovative Editions at Rutgers, the State University of New Jersey
Two inkjet prints with gold leaf on paper | Each 51 × 76 cm | V&A: E.163:4-5–2009 | Purchased through the generous support of the Friends of the V&A

From 2001 to 2003, Isaac Julien developed a collaborative multi-media project in the city of Baltimore, Maryland, working across three institutions: the Great Blacks in Wax Museum, the Walters Art Museum and the (now defunct) Contemporary Museum. Julien produced a triptych film set in a near-future Baltimore, using the tropes of 1970s 'blaxploitation' cinema as well as the Afrofuturist sensibilities that evoke time travel and displacement. To achieve the work, Julien literally displaced a number of history-making likenesses from the wax museum and positioned them strategically in the Walters galleries in such a way that the figures appear to contemplate the Old Master paintings displayed on the gold-fabric covered walls. The final work was shown at the Contemporary Museum in film and photography, and through a selection of wax figures on loan.

In these images, the figure regally dressed in purple is Baltimore gospel singer Pauline Wells Lewis, referred to locally as 'Aunt Pauline' or the Godmother of Gospel. The female figure dressed more soberly in the black trouser suit is activist Bea Gaddy. Known as St Bea, or the 'Mother Teresa of Baltimore', she overcame her own impoverished beginnings and led a successful crusade against homelessness and deprivation. In the second image, Lewis and Gaddy are joined by Baltimore native Kweisi Mfume, former president of the National Association for the Advancement of Colored People (NAACP). The figures Julien selected bring into the frame religion, society and culture – both so-called 'high' culture and more marginalized manifestations of black cultural achievement and local history – posing questions about the memorialization and representation of history. He orchestrates a cultural meeting point in which the Great Blacks in Wax Museum exists 'not just as a museum but as an artwork'.[1]

Serving almost as preparatory sketches, Julien produced a series of eight sets of digital prints that are not stills from his filming but images captured with a medium format camera. These two images from that series were re-purposed to form part of the Rivington Place portfolio as a means of championing cultural diversity in the arts. This portfolio was issued in a limited edition to raise funds for two organizations. Firstly, Rivington Place, designed by architect David Adjaye as a permanent home for Iniva (Institute of International Visual Arts), established in 1994 'to address an imbalance in the representation of culturally diverse artists, curators and writers'.[2] Secondly, Autograph ABP, established in 1988 as an agency to assist and raise the profile of black photographers working in Britain but which latterly has become more broadly involved with human rights issues globally.

Untitled forms a fitting link to Julien's initial reaction to the Great Blacks in Wax as a 'museum space which was articulating in a very astute and very moving way a history of a people. And it's very involved in the question of memorialization.'[3]

1. Eric Allen Hatch, *Baltimore City Paper*, 6 February 2004.
2. Iniva mission statement: http://www.iniva.org; access date 7 May 2013.
3. Hatch (cited note 1).

Hew Locke (born 1959)

The Prize, 2006–7

From the Rivington Place portfolio | Printed by Randy Hemminghaus
Published by the Brodsky Center for Innovative Editions at Rutgers, the State University of New Jersey
Digital prints with screen print collaged into a 3D structure, with plastic beads and flowers; 27/50
V&A: E.163:7–2009 | 76 × 51 × 12.5 cm | Purchased through the generous support of the Friends of the V&A

This print was transformed with great skill and ingenuity into an edition by master printer Randy Hemminghaus and his team at the Brodsky Center. In its use of mixed media and collage it is representative of Hew Locke's characteristic practice in which he uses found or throwaway materials for sculptural constructions. *The Prize* is a complex and fragile work of cut and woven paper parts, involving photography, screen-printing, and digital and manual cutting and pasting, the whole construction resembling a three-dimensional jigsaw. The form is based on a chalice Locke saw in the V&A, here transformed into something flimsy and flashy with plastic 'gold' beads

and plastic flowers, intended to suggest the metaphorical hollowness of trophies and their devalued status in our society. It also alludes, obliquely, to ideas of looting, the forcible taking of 'trophies' and 'prizes' that accompanied much of the enterprise of imperialism and filled Britain's museums with treasures from other cultures. The words 'get well soon' are repeated in the pattern of the print with satiric intent; this sentiment, taken from mass-produced greetings cards, themselves as kitsch as the faux glitz of the baubles adorning the chalice, expresses the hope that the debilitating lust for power and wealth might itself be cured.

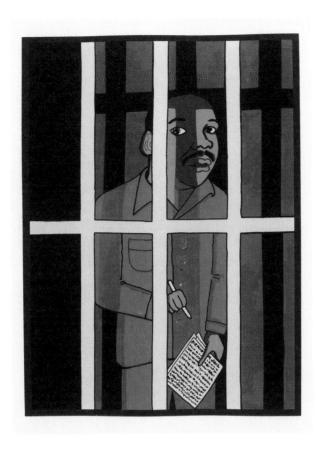

Faith Ringgold (born 1930)

Letter from Birmingham [USA] City Jail, 2007

Published by Limited Editions Club | Colour screen prints (8) | Closed book 36.9 × 31.2 cm | V&A: National Art Library 805.AL.0009

Letter from Birmingham City Jail, with its eight commissioned prints, was to be the final *livre d'artiste* completed before the death of Sidney Shiff (1924–2010), the publisher of Limited Editions Club. Founded in 1929, the Club's aim was 'to publish finely made and finely illustrated limited editions of the classics of literature – and of a few carefully selected contemporary titles.'[1] In 1978, after a series of changes in ownership, Shiff acquired it, shifting the focus to artists' books. Eventually restricting publication to four or fewer books per year, he commissioned leading contemporary fine artists, often publishing texts of the artists' own choosing. Shiff championed the work of African diaspora artists (including Romare Bearden, Phoebe Beasley, John Biggers, Elizabeth Catlett, Allan Rohan Crite, Lois Mailou Jones, Jacob Lawrence, Dean Mitchell, Betye Saar, John Wilson), writers (Maya Angelou, Langston Hughes, Zora Neale Hurston, Leopold Sedar Senghor, Derek Walcott, Margaret Walker, Richard Wright) and even presented an original jazz recording by Wynton Marsalis.

Of all the Limited Editions Club artists, Faith Ringgold felt a particular affinity to Martin Luther King's rallying cry for civil rights. In her autobiography, Ringgold details 1963 as a watershed year: 'James Baldwin had just published *The Fire Next Time*, Malcolm X was talking about "us loving our black selves," and Martin Luther King Jr. was leading marches and spreading the word. All over this country and the world people were listening to these black men. I felt called upon to create my own vision of the black experience we were witnessing … I had something to add – the visual depiction of the way we are and look […] to express this moment I knew was history. I wanted to give my woman's point of view to this period.'[2]

On 16 April 1963, Martin Luther King wrote his Letter from Birmingham City Jail, one of the most important pieces of correspondence ever, in response to claims from Dr King's fellow clergymen that efforts for black civil rights were 'unwise and untimely'. Ringgold's visualizations of key passages in the text – white church-goers sitting idly by while the stained glass windows reveal shadows of black men under attack from police dogs; the spirits of four murdered girls soaring over a church bombed by white supremacists; the yearning of black children to access a segregated amusement park – perfectly complement the impassioned, yet eloquently measured, words.

1. Bill R. Majure, *A Brief History of the Limited Editions Club* (Madison, ME., 2005); www.majure.net/lechistory.htm; access date 30 May 2012.
2. Faith Ringgold, *We Flew Over the Bridge* (Boston, ME., 1995), p.146.

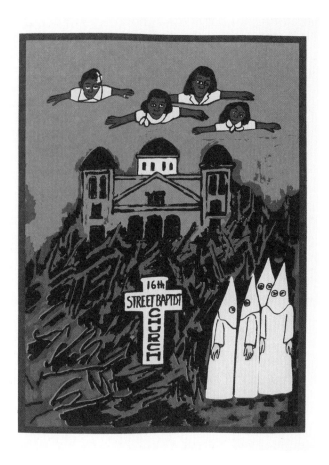
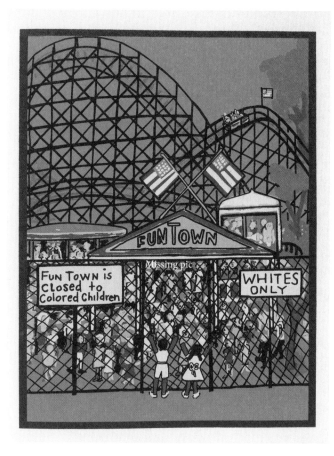
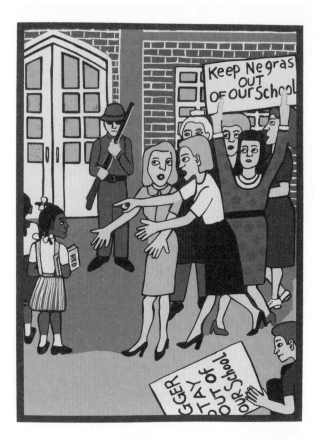
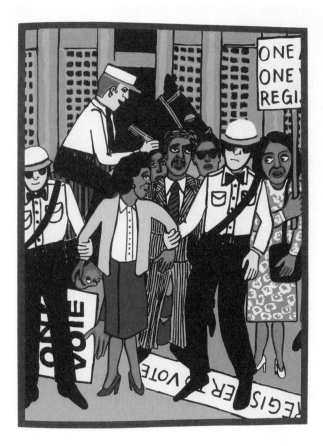

MEMORY

Wilfredo Lam (1902–1982)

Composition, 1961

Colour lithograph; 37/50 | 55.9 × 76.2 cm | V&A: E.2784–1962

Wilfredo Lam is considered Cuba's foremost modern master, working primarily across painting, ceramics and bronze but showing a sustained interest in printmaking from the 1960s. After collaborating with master printer Giorgio Upiglio at Grafica Uno studios in Milan, Lam made print an important aspect of his own work for the rest of his life. Known primarily as a surrealist, creating subjective interpretations of rough, totemic forms, Lam used his Afro-Latin heritage to inform the structure, rhythm and meaning of his works. A collector of African and Oceanic art, he merged into his modernist aesthetic symbols recalled from participation in Santeria practices in his youth as well as travels to Haiti later in life, which allowed him to observe voodoo ceremonies for the first time.[1] 'Some people say, quite wrongly, that my work took on its present form in Haiti. But my sojourn there merely broadened its range, as did my visits to Venezuela, to Colombia or to the Mato Grasso in Brazil. I could have been a good painter of the School of Paris, but I felt like a snail out of its shell. What has really broadened the range of my painting is the presence of African poetry.'[2]

This print, with its *trompe-l'oeil* burlap effect, is dominated by a brown polymorphic figure, recurring for Lam in various forms as a symbol of the union in humanity of life and death, the animal kingdom and plant life. Lam once declared, 'we are joined by a thousand umbilical cords, immersed in an infinite material process, death is a part of life itself, it marks the transformation of elements.'[3] This figure overlaps other hybrid forms in yellow and green, respectively.

1. Santeria refers to an Afro-Cuban syncretic belief system blending the religion and customs of the Yoruba people with elements of Roman Catholicism.
2. Max-Pol Fouchet, *Wilfredo Lam* (Barcelona, 1989), pp.8, 209–10.
3. Ibid.

John Lyons (born 1933)

Jab Jab, 1988

From the *Jouvert* portfolio | Published by Paddington Printshop, London | Screen print; 14/23 | 56.5 × 76 cm | V&A: E.1238–1995

Painter and poet John Lyons was one of 50 artists commissioned by John Phillips of Paddington Printshop to make a print for the *Jouvert* portfolio, published in 1988 to celebrate the spirit of Carnival. 'Jouvert' is Trinidadian patois from the French 'J'ouvert', which translates literally as 'day open' and by extension, 'dawn' or 'beginning'. This was an apt subject for Lyons: 'Mas' (masquerade) has been an enduring theme in his work. In the vivid reds, pinks and yellows of this print he evokes the heat and colour of Carnival in his native Trinidad. The central figure here is Jab Jab (originally Djab, from the French, 'diable'), a devil disguised as a clown; his dance is sexually aggressive and asserts an appetite for mischief.

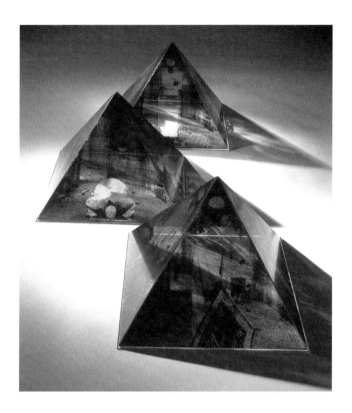

Faisal Abdu'Allah (born 1969)

Thalatha Haqq (Three Truths), 1992

Screen prints (3) on pyramidal sheet glass; unique work | Each 56 × 56 × 56 cm | V&A: E.1886-8–1993

In 1992 Faisal Abdu'Allah travelled to Spain, where he stayed in the flat in Barcelona owned by the Royal College of Art for the use of its students. The trip ended up being 'a type of spiritual quest'.[1] Struck by the quality of light in an alleyway, he returned to the same location at the same time the following day to be photographed in prayer.

Having converted to Islam the previous year, the artist was preoccupied with issues of identity and dislocation as well as African and Islamic philosophies:

> I went to the mosque one particular Friday for prayers and the Imam's Khutbah [sermon] was centred on issues of truth. This really resonated for me because it was what my life's quest and artistic journey was all about at this point. He was breaking down the notion of 'Truth' into relative truths: your truth; my truth and the truth. I began to make associations with my upbringing, with my father and my childhood spent in the Pentecostal Christian church. I also saw these relative truths repeated in the Holy Trinity of the Father, the Son and the Holy Ghost. My understanding of the spiritual world housed itself physically in the pieces I started to make, for me it was about making tangible what was previously intangible.

Inspired by what he heard, Abdu'Allah used the prayer photographs as the basis for this innovative series of prints. 'The first photograph is me standing in prayer; my truth. The second is sadjah, the kneeling prayer; me submitting myself with respect and humility to your truth. The third is me taking the prayer mat away, the act of removing myself is open-ended and incomplete; the truth.' He went on:

> I mixed things into the printing ink – colleagues from my mosque would bring back holy water from their travels. I mixed this in the printing ink to 'charge' the work. Every making process is a ritual for me. Printing *Thalatha Haqq* took me a whole day to prepare: a series of prayers before I started, then I'd print one screen while reciting a prayer. Each panel was prayed over – and they each came out perfectly the first time. I didn't have to clean or re-ink the screens.

The use of sheet glass as printing surface emerged through Adbu'Allah's desire to recapture the elusive and transformational quality of light as experienced in Spain. 'In Islam, the idea of Nour or light is very important. Muslims pray at prescribed times of day based on phases of light. Light passes through the glass forms and reflects light. It throws images trapped within a fragile surface. I was a fragile soul, leaving behind one way of life and moving toward another new way of life.'

1. All quotes taken from an interview with Zoe Whitley, 13 July 2012.

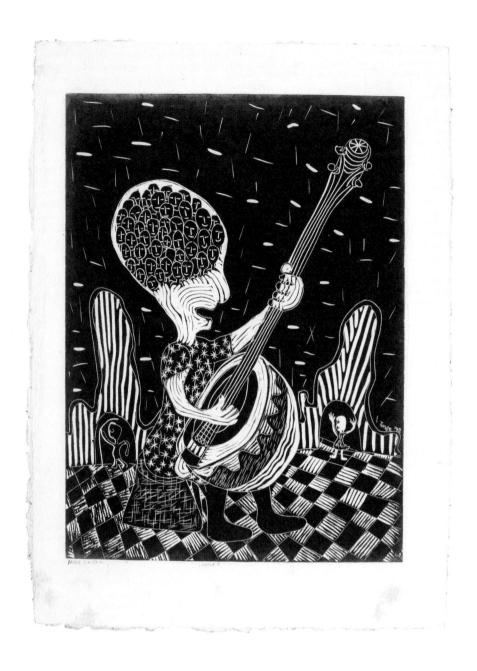

Tunde Odunlade (born 1954)

The Music Lesson, 1992

Linocut | 76 × 55 cm | V&A: E.1239–1995

Tunde Odunlade is one of the leading figures in the resurgence of traditional African art that came out of Oshogbo, Nigeria, in the late 1960s. As a visual artist he works with textiles and batik as well as paint and print; he is also an accomplished musician, who plays several instruments and manages his own music and dance troupe.

He was introduced to printmaking by the Austrian artist Suzanne Wenger and her husband, writer Ulli Beier, who set up workshops in Oshogbo in the early 1960s, where practitioners from Europe taught a range of print techniques. These various influences – textiles, music, European modernism, and the character of the linocut process itself – are reflected in this print, which is animated by bold contrasts and a variety of patterns and textures.

Kara Walker (born 1969)

Freedom: a fable …, 1997

Laser-cut paper; un-numbered, from an edition of 4,000 | V&A: National Art Library X990038 | Closed book 23.8 × 21.3 cm | Given by the artist

'The future vision of a soon-to-be emancipated nineteenth century Negress' is the opening line of this pop-up book of laser-cut silhouettes. It details the story of unnamed female slave N--- and her determination to 'become a god […] seeking to rewrite history.' Juxtaposed with her master's brutality and sexual abuse, her visions of Africa loom large. Fantastical ideals merge with sexual dreams.

Kara Walker's black paper typologies are simultaneously beguiling and repellent, reflecting the complex emotions brought about by subjugation, fear and hunger on the one hand and hope, defiance and desire on the other. N--- speaks to her compatriots, addressing their shared history in bondage and the forging of new beginnings away from 'our father, that peculiar institution, that left us here to rebirth our own bodies …'. The artist has garnered both critical acclaim and community reproach for her exquisite and exaggerated depiction of racial stereotypes. In one particularly evocative image, a palm tree merges phallically with N---'s naked body as she reflects on what life could be in the Reconstruction era.

The artist's book, Walker's first, was commissioned for the 1997 Peter Norton Family Christmas Art Project, an annual event begun in 1988 which commemorates the holiday season with an original work of art by an artist represented in the Nortons' private collection. Sent to business associates, friends, family and art world colleagues, its guiding principle is to make contemporary art accessible on a personal scale.

As with all of Walker's *oeuvre*, *Freedom: a fable …* blurs fact and fiction, trauma and parody. She appropriates archaic turns of phrase and imagery from popular Civil War-era prints and printed ephemera, such as those featured in *Harper's Weekly*. Ultimately, the title can be read as a statement rather than a description: throughout African-American history, the very idea of freedom could be paramount to make-believe.

oh don't you know that it hurts so good

don't you know that it hurts so good

you know that it hurts so good

it hurts so good

Sonia Boyce (born 1962)

Lover's Rock (detail), 1998

Produced by Early Press, on paper supplied by Sanderson plc | Lengths of blind-embossed wallpaper (6) | Each 305 × 56.2 cm | V&A: E.463-468–1999

Like the works in Sonia Boyce's *Devotional* series (see p.76) this suite of wallpaper panels was inspired by popular music. 'Lover's Rock' is a style of reggae characterized by romantic lyrics. The only decorations on each length of white paper are a series of words that appear at about hip height when the paper is hung. These have been blind-embossed (printed or stamped into the paper without using any pigment, to produce a pattern in relief). The words come from Susan Cadogan's hit 'Hurt So Good' (1975), a song that became popular at West Indian house parties in the 1970s. Boyce recalls going to such parties where, when this song was played, dancing couples would sway and rub up against the walls, responding to the intense sensual message of the music. As a result the wallpaper would be marked, even worn away, at hip height all around the room. Boyce's wallpaper, which invites touch, subtly evokes and commemorates this tactile encounter between bodies and walls, and the fugitive traces left behind.

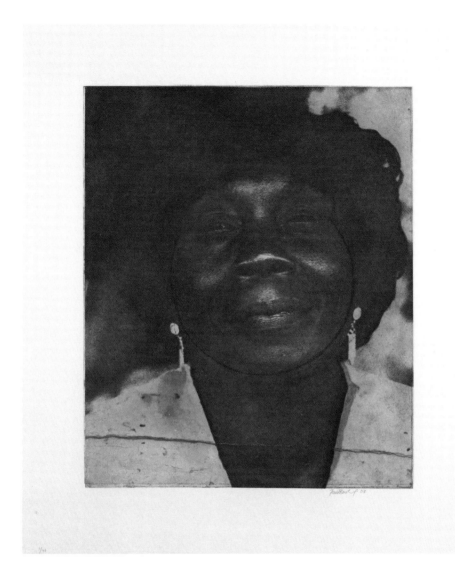

Frank Bowling (born 1936)

Mother Approaching Sixty, 2003

Printed by Randy Hemminghaus at David Krut Editions, New York | Photo-etching, soft-ground etching and spitbite aquatint; 1/40
88.3 × 77.5 cm | V&A: E.3581–2004 | Purchased through the Julie and Robert Breckman Print Fund

Frank Bowling came to Britain from Guyana in his mid-teens and was awarded a scholarship to study painting at the Royal College of Art in 1959. His early figurative work was succeeded by a signature style of abstraction, rooted in landscape but inflected by personal memory and history. He has achieved several art world 'firsts': in 1987 when the Tate acquired a painting by Bowling, it was the first work they had ever bought by a living black British artist, and in 2005 he became the first black artist elected to the Royal Academy.

In 2003 Aljira, a centre for contemporary art in Newark, New Jersey, staged a retrospective for Bowling – and he made this print as a fundraiser. Though he left his family while young, Bowling remained close to his mother and this print stands as homage to her influence on his life and work. She had been a seamstress, with a thriving business, and traces of this life recur in his paintings, in canvases cut with pinking shears, or with needles and thread embedded. This portrait is a reworking of a 1960s piece, not developed at the time, in which a photograph of his mother was transferred to two silk screens, layered one over the other. Here the doubled silk-screen image has been etched, and printed with wiped-out borders around the face, creating effects of texture and translucent colour familiar from his paintings. The additions of a red circle and a line read as references both to thread and to paint.

Chris Ofili (born 1968)

After the Dance, 2006–7

From the Rivington Place portfolio | Printed by Randy Hemminghaus
Published by the Brodsky Center for Innovative Editions at Rutgers, the State University of New Jersey
Colour screen print; 27/50 | 76 × 51 cm | V&A: E.163:8–2009 | Purchased through the generous support of the Friends of the V&A

Encountering this intimate moment between two silhouetted figures dancing on a beach, lit as if by the twinkling stars and an unseen moon overhead, time appears to stand still. Movement is suggested by the footprints in the foreground, gentle undulation on the surface of the water and perhaps the quiet rustling of palm fronds. Overall, the effect is one of quiet tenderness.

Chris Ofili is best known as a virtuoso painter, but printmaking lends valuable flexibility to his practice. 'I think the process of printmaking actually can inform painting in that one can make a lot of changes constantly throughout the process of making prints.'[1] Reflecting on time and timelessness in his work: 'I might be working on a subject – it can be made up, come from another painting of mine, or another artist's work. I find a way to translate it into my own experience. Often I look at my paintings and I don't know if they feel like the present day, if the time that I'm living in now is actually the time that I'm painting.'[2] Created in 2006 for the Rivington Place portfolio, this screen print directly references Malian photographer Malick Sidibé's *Nuit de Noel*, a portrait taken in 1963 of a young, stylish couple dancing at a Christmas party. Ofili owns a print of the photograph and his composition strikingly mirrors the original: they each depict a couple with their heads bowed toward one another, feet angled in mid-step, the woman elegantly barefoot wearing a full skirt. A more surprising reference for the creation of *After the Dance* has more humble origins: the printed illustration on a dry-cleaning bag of 'a couple looking at each other,

with a drawing of a palm tree and a sunset. I quite liked it, and I did a few drawings of it. It was around that time I first came to Trinidad. Two sparks came together, I got a little bit of a flame, and that became the guiding light.'[3] Indeed light is the other resonant feature of this print. It was created a year after the artist relocated permanently to Trinidad in 2005, upon feeling that his *oeuvre* had become 'crystallized'.[4] Ofili has spoken of capturing the beguiling quality of light on a beach at night: 'You see shapes where you can't quite tell if you're seeing a figure or an animal or a leaf.'[5] Finding night-time to have a particularly transformative effect on an equatorial island where there are equally 12 hours of daylight and moonlight each day, the print's subtle shifts in tonalities of blue ink do indeed harness a peaceful inscrutability.

1. Chris Ofili at Crown Point Press (2009); see https://www.youtube.com/watch?v=JArpnu8z8kk; access date 1 May 2012.
2. Quoted from Peter Doig and Chris Ofili interview, *BOMB* (Fall 2007), issue 101: http://bombsite.com/issues/101/articles/2949; access date 1 May 2012.
3. Adam Sternbergh, 'Aftershock', *New York Magazine*, 21 May 2005; http://nymag.com/nymetro/arts/art/reviews/11877; access date 1 May 2012.
4. Chris Ofili, *Guardian* video interview, 3 February 2010.
5. Doig and Ofili (cited note 2).

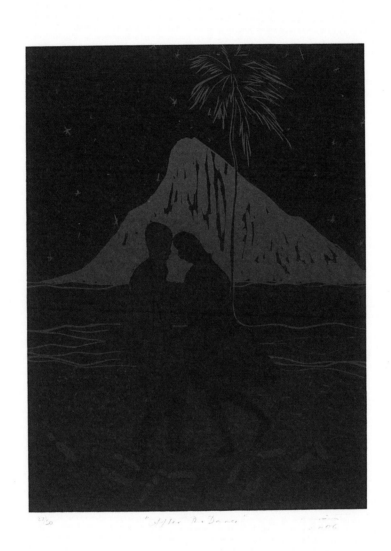

Sonia Boyce (born 1962)

1930s to 1960s, 2006–7

From the Rivington Place portfolio | Printed by Randy Hemminghaus
Published by the Brodsky Center for Innovative Editions at Rutgers, the State University of New Jersey
Hard- and soft-ground etching with spitbite aquatint; 27/50 | 76 × 51 cm | V&A: E.163:3–2009
Purchased with the generous support of the Friends of the V&A

Sonia Boyce, who began her career as a painter, has subsequently moved into installation projects that often involve collaboration and performance. This print draws on reminiscence sessions where a group of women (led by Boyce) pooled their memories of black British female singers. It belongs to a larger project, the *Devotional* series, for which Boyce has adapted the imagery to different contexts, including a wall drawing at the National Portrait Gallery (2007) and a silk-screened wallpaper (2008). The linear 'haloes' around each name enact a rhythmic pattern reminiscent of the grooves in vinyl records, and conjure the idea of sound waves. Like contour lines on a map, they also evoke the embedded place of music in women's lives. The fuzzy, imperfect star shapes, overlaid in soft-ground etching, suggest the haziness of recollection and the fluctuating status of these one-time 'stars' of popular music.

Avril Coleridge-Taylor

Muriel Smith

Elizabeth Welch

Pearl Prescod

Pauline Henriques

Winifred Atwell

Adelaide Hall

Nadia Cattouse

Shirley Bassey

P. P. Arnold

Cleo Laine

Madeline Bell Blurvik

Audrey Hall

Millie Small

IDENTITY

John Ndevasia Muafangejo (1943–1987)

Noah's Ark, 1979

Linocut on paper; 25/150 | 92 × 65 cm | V&A: E.433–1982

John Muafangejo was one of the first artists in southern Africa to work professionally as a printmaker, thanks to his introduction to the linocut process at the ELC Art and Craft Centre at Rorke's Drift in South Africa in the late 1960s. As a Kuanyama, a sub-tribe of the Ovambo people, living on the border between Namibia and Angola, Muafangejo used the medium of print to address the region's history of conflict as well as more personal subjects – his family and childhood, his ancestry and Africa's colonial history, the struggles of daily life and the aspirations of contemporary liberation movements. His conversion to Christianity and his education in Anglican mission schools had a direct influence on his work. Many of his densely detailed prints illustrate stories from the Bible, but interpreted from a distinctly African perspective. Here his version of Noah's Ark is populated with African animals, including giraffes, elephants and kudu. This print is characteristic of Muafangejo's signature style, incorporating a panel of text and crowding a multitude of figures into the confines of the block, the whole composition divided into separate frames to show different aspects of the narrative simultaneously.

Timo Lehtonen (born 1953)

Mobocracy, 1988

Monotype | 56.5 × 76 cm | V&A: E.1234–1995

Timo Lehtonen was born in Helsinki of Finnish and Nigerian parents, and has lived in both countries, although he is now based in Britain. Subjects and motifs derived from, or inspired by, his connections with Africa permeate his work. Issues of identity and coded allusions to the effects of cultural deracination are also a recurrent theme. In an article for *Printmaking Today* (2001) Lehtonen quotes Robert Hughes' view that 'Abstraction is a sign for the emotional state of deracination, of not belonging'; he then goes on to speak of his own work as an 'attempt to illuminate the relationship between creativity and a sense of belonging'.

Here he presents a frieze of semi-abstract figures, shadowy and insubstantial, their ghostly character achieved by drawing in solvent-released ink and wax crayon on the screen. Resembling a series of hieroglyphs, they allude to the human figure, and reflect diverse influences – ranging from Picasso on the one hand to the San rock art of southern Africa on the other. The figures have a playful cartoon-like spirit, but the title *Mobocracy* hints at a more sinister interpretation, suggesting a state ruled by the mob.

Detail: *Kaylynn Sullivan/Scarlet with embarrassment* Detail: *Sam Gilliam/Black depression*

Adrian Piper (born 1948)

Colored People artist's book, 1991

Published by Bookworks, London; from edition of 100 | Colour offset lithographs | Closed book 28 × 21.5 cm | V&A: National Art Library X950082

In 1987 Faith Ringgold and Margaret Gallegos initiated a collaborative artists' book project, which resulted in a touring exhibition called *Coast to Coast: A Women of Color National Artists' Book Project*. Leading conceptual artist Adrian Piper was among the 200 artists of Hispanic, Native American, Middle Eastern, Asian and African descent taking part.

Piper created for the exhibition a mock-up for *Colored People*, which was published in an edition of 100 by Bookworks in 1991. The artist invited 16 collaborators (Houston Conwill, Kinshasha Conwill, Jane Farver, David Frankel, Sam Gilliam, Kellie Jones, Lucy Lippard, Rosemary Mayer, John Moore, John Morita, Clive Phillpot, Howardena Pindell, Lowery Sims, Kaylynn Sullivan, Judith Wilson and Josephine Withers) each to take eight self-portrait photographs corresponding to a colloquial turn of phrase that uses colour to describe an emotional state. The moods designated by Piper were: tickled pink; scarlet with embarrassment; purple with anger; blue; green with envy; jaundiced yellow; white with fear; and black depression.

What emerges is a fascinating collection of unique moments of self-presentation and convergence, such as the preponderance of downcast eyes in the 'black depression' images. The artist layered her own interpretation over their likenesses with spot colour. She achieves a balance between the seriousness of the social subtext – where traditional Manichaean moral dualities of white/black, good/bad, light/dark, happy/sad, ascribe rigid values and prejudices – and the lack of self-importance demonstrated by those willing to lay themselves bare before the camera. For Piper, the project was 'a light-hearted conceptual gesture with serious implications'.[1] *Colored People*, involving as it does a number of Piper's fellow art world figures, also playfully turns on its head colour-loaded language so often imposed upon artists who choose to deal with race and politics in their work. On her 64th birthday, on 20 September 2012, Piper reprised these experimentations with colour and language via a digital self-portrait, titled *Thwarted Projects, Dashed Hopes, A Moment of Embarrassment*. With this work she declared her retirement from 'being black': 'my new racial designation will be neither black nor white but rather 6.25% grey, honoring my 1/16th African heritage … Please join me in celebrating this exciting new adventure in pointless administrative precision and futile institutional control.'[2]

1. www.bookworks.org.uk/node/26; access date 30 June 2012.
2. www.adrianpiper.com/news_sep_2012; access date 20 September 2012.

Detail: *Houston Conwill/Blue*

Detail: *Lowery Sims/Green with envy*

Margo Humphrey (born 1942)

The History of Her Life Written Across Her Face, 1991

Colour lithograph and collage on paper; 19/30 | 81 × 74.5 cm | V&A: E.2833–1995 | Given by Judith Brodsky

This large format tour-de-force print brings the viewer face-to-face with poignant personal moments from master printmaker Margo Humphrey's own life. Graduating with honours from Stanford University, California, in 1972 with an MFA in Printmaking, she established herself as a key figure in the renaissance of professional printmakers then taking place in the San Francisco Bay area. Energized by the technical challenges of lithography in particular, a white-male dominated technique, Humphrey established an international reputation that led to numerous awards and to teaching printmaking not only in the United States but also in Fiji, Nigeria, South Africa, Uganda and Zimbabwe.

This vivid composition is the result of more than three years of preparatory drawings, preserved visual and textual references and handwritten notes. One of the most enduring references was an image Humphrey found in a copy of *National Geographic* of a woman's face tattooed with a Sanskrit prayer. The finished work alludes to the simultaneous acts of concealment and self-presentation that veiled women deftly negotiate.

Synthesizing artistic influences as wide-ranging as Works Progress Administration-era muralist Charles White, missionary folk artist Sister Gertrude Morgan, painter Jean-Michel Basquiat and jazz musician Rahsaan Roland Kirk, a visual autobiography emerges that chronicles the artist's path as a woman, a mother, a lover and as an African American.[1]

Humphrey has described the print as having a confessional and transcendental power, 'like a prayer. In some religions you recite the same thing over and over to elevate yourself to a certain spiritual level. The more you recite the more you unburden […] the freer you are. When you are free you can experience almost anything. The image then became an expression for the things that all women go through and the fact that women need to use experience toward character building, not consider it as an obstacle. The image is about empowerment and the projection of oneself forward, about oppression as a vehicle for self-expression, and about the physical and inner-beauty of African-American women.'[2]

1. Adrienne L. Childs, *Margo Humphrey: The David C. Driskell Series of African American Art* (Petaluma, CA., 2009), vol.VII.
2. Nancy E. Snow, *The Art of Democracy / The Democracy of Art*, Crossing Over Consortium (Spring/Summer 1994); http://www.helenfrederick.com/index.php?/documentation/the-art-of-democracy; access date 15 June 2012.

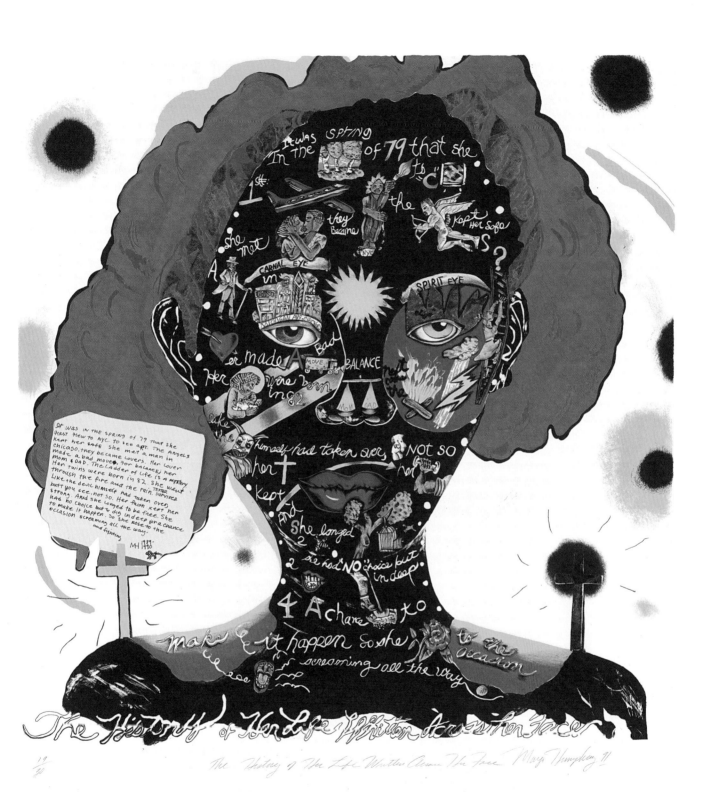

Carrie Mae Weems (born 1953)

Looking High and Low, 1993

Screen print on wallpaper | 994.5 × 67.5 cm | V&A: E.262–1993 | Given by the artist

Carrie Mae Weems made this wallpaper as part of an installation, *The Apple of Adam's Eye*, at the Philadelphia Fabric Workshop in 1993. The pattern is taken, unchanged, from a woodcut design by the English illustrator John Farleigh (1900–1965), which was used for the endpapers of George Bernard Shaw's novel *The Adventures of the Black Girl in Her Search for God*, first published 1932. Weems felt that this small-scale repeat, almost abstract in its graphic economy, was an apt backdrop for a photographic record of her own spiritual odyssey to the slave ports of West Africa. As she put it in an interview with curator Thomas Collins, 'I was a subject in search of myself and attempting to map a new psychological terrain for myself and others.

I suppose […] I'm trying to construct a new prism for looking at certain aspects of African American culture.'[1] As she goes on to say, 'the wallpaper is a metaphor for the searching, probing, looking.' In her appropriation, or taking back, of a white artist's 'Africanizing' design in this context, she highlights the historic European appropriation of Africa, its people, culture and resources – her own heritage.

1. Thomas Collins and Carrie Mae Weems, leaflet to accompany the display *Projects*, Museum of Modern Art, New York, November 1995–January 1996, n.p.

Faisal Abdu'Allah (born 1969)

Nubian Hood, 1993

Screen print; 9/50 | 27.9 × 28 cm | V&A: E.615:4–1996 | Given by the Royal College of Art

Faisal Adbu'Allah bears the distinction of having developed a successful career as an artist while maintaining his status as a sought-after barber in Harlesden, north London. Trained at Harrow School of Art and Central Saint Martins, followed by the Royal College of Art, Abdu'Allah initially charted a career for himself in design: 'It seemed to me that was where the money was, in graphic design.'[1] The quality of his work at Harrow set him apart and he was encouraged by his teacher Sue Rosso to pursue fine art rather than graphic design. 'She's the first person who told me I was an artist.'

While at Central Saint Martins, Abdu'Allah spent part of his undergraduate study at Massachusetts College of Art in the United States and was exposed to African-American culture in part through his fellow black students there. It was also during his time in the United States that he discovered Islam, through the charismatic radio voice and controversial oratory of Louis Farrakhan, leader of the mainly African-American religious movement, the Nation of Islam. Abdu'Allah became a convert and changed his name to that by which he is now known.

The African-American barbershops in particular proved to be a locus of culture and identity for black males: a space for debate, creative exchange and fraternity. Largely self-taught, Abdu'Allah used the graphic design principles he learned at Harrow to help articulate a creative outlet for young men – their hairstyles. 'The application didn't seem a lot different from what I was learning, almost like drawing.' So he began to cut hair, adopting the principles of line, proportion, form and the assertion of identity he also explores in art.

1. All quotes taken from an interview with Zoe Whitley, 13 July 2012.

Ken McDonald (born 1951)

Untitled, 1998

Printed by London Printworks Trust for the exhibition *Masquerade* | Woollen coat lined with screen-printed satin (unique)
v&a: e.286–2005 | Length of coat 100 cm, opening to 148 cm | Purchased through the Julie and Robert Breckman Print Fund

Masquerade, commissioned and curated by London Printworks Trust, was an interactive exhibition that took the form of a pop-up boutique in Brixton Market, south London. It was designed to investigate and demonstrate the ways in which clothing can reflect or alter the wearer's personality and identity, and influence the perceptions of others. The show gave visitors the opportunity to dress up and play with different roles, and in particular to challenge stereotypes based on appearance.

Ken McDonald made this piece for the event. He took a worn and dirty old coat, which he had found discarded in the street, and added a sumptuous silk lining screen-printed with an image from an altarpiece, the *Madonna and Child with Saints Julian and Lawrence* by Gentile da Fabriano (1370–1427). McDonald was not a trained artist or a designer but rather a bespoke tailor, who had been involved with a range of creative activities in the 1980s. His transformation of the shabby coat dramatized the idea that outward appearances should not be taken as a measure of character or moral worth. By choosing a religious image, he also suggests that the modest and self-effacing may be more spiritual than those who parade their wealth.

Maria Magdalena Campos-Pons (born 1959)

Untitled, 1999

Colour photogravure on handmade paper; 9/14 | 51.4 × 44.5 cm | V&A: E.878–2003
Purchased through the Julie and Robert Breckman Print Fund

This unconventional self-portrait was made by one of Cuba's leading contemporary artists. In 1976 Cuba established a Ministry of Culture, which better enabled artists on the island to have their work appreciated by an international audience.

Maria Campos-Pons applies a syncretization of African and European practices in her work, incorporating West African visual traditions from Yoruba, Ewe and Ejagham cultures, among others. This colour photogravure on handmade paper can be interpreted variously as the role of the artist's eye – seeing and in turn, being seen. The artist's own back is layered with images of eyes. Campos-Pons allows herself to be subject to our gaze but on her own terms – she denies the viewer her face and has a myriad eyes peering back at us. The eye, echoed in shape by cowrie shells, may also suggest Elegba, the male Yoruba Orisha (a spirit or deity), who is frequently depicted with cowrie-shell eyes. The female Orisha Oshun also comes to mind, as she rules fertility and is often associated with peacock feathers and their decorative 'eyes'.

Chris Ofili (born 1968)

Regal, 2000

Printed by Omnicolour, K2 Screen and Print Select | Published by Counter Editions
Lithograph and screen print from digitally-merged watercolour and etching; 15/300 | 29 × 40 cm
V&A: E.1570–2001 | Purchased through the Julie and Robert Breckman Print Fund

This striking print combines traditional and digital print processes to capture the fluency and translucent colour of Chris Ofili's watercolours. The effect is further enhanced by over-printing the background with phosphorescent 'glow in the dark' ink. It relates to a series of intimate small-scale watercolours – head and shoulders 'portraits' of men and women – collectively entitled *Afromuses*, which Ofili produced between 1995 and 2005.

As the series title suggests, the subjects are distinctively African, in their dress, accessories and hairstyles, and clearly informed by the counter-cultural ideals of black style and beauty that surfaced in the 1960s and 1970s. Throughout his career Ofili has appropriated stereotypes of black people and black culture, often controversially, but his work defuses caricature and cliché through a nuanced use of sources and his creative use of emphasis and exaggeration. This print is a case in point. The figure with his clipped Afro hairstyle, full pointed beard and richly ornamented garments has the dignified bearing of a ruler. While inspired by African precedents, such as photographs by Malian photographer Seydou Keïta, this print and its watercolour counterparts also draw on a tradition of formal portraits dating back to court painting of the Renaissance.

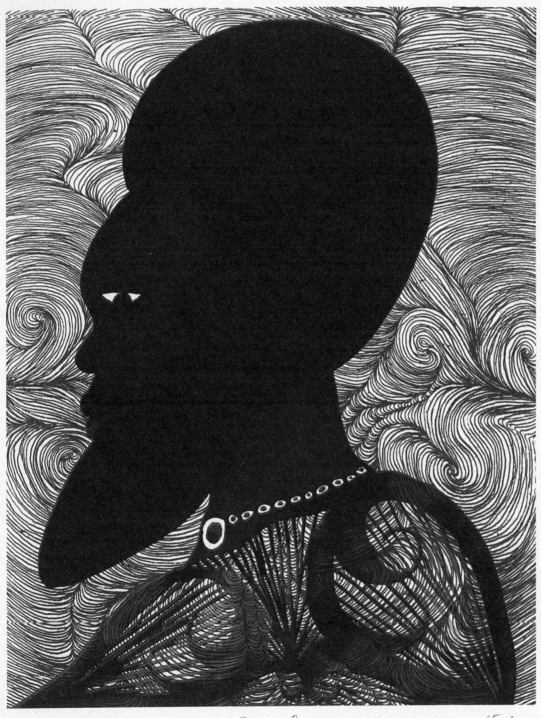

Regal 15/300

Joy Gregory (born 1959)

FlyPitch: Celebrity Blonde, 2003

Cyanotypes with mixed media collage (5) | Various: 11.5 × 16 cm (3); 8.3 × 8.3 cm (2)
V&A: E.1133-1137–2012 | Given by Rosie Miles

Having found few cultural representations of black female beauty while growing up, Joy Gregory began her career as an artist by creating them for herself, in compelling photographic self-portraits. The complexities and contradictions of contemporary norms of beauty have played an important role in the artist's oeuvre, namely through the examination of societal pressures that can compel women to conform to Western ideals of female presentation, as revealed through the politics of hair straightening and hair dyeing.

Gregory has explored this theme through such works as the photographic series *Objects of Beauty* (1992–5), the interactive online art project *The Blonde* (1997), conceptual installation *Bottled Blonde* (1998), ongoing video document *The Fairest* (since 1998) and *Celebrity Blonde* (2003), of which these prints form a part. Sensitively harnessing varied viewpoints as social commentary, Gregory mines the beauty industry and personal reactions to it for sources of vulnerability, self-esteem and empowerment in personal identity.

FlyPitch was conceived as an innovative artists' project based in Brixton Market, where contemporary artists could sell their art to shoppers among stalls for everyday groceries and provisions. The market is surrounded by a preponderance of hair salons and beauty supply stores catering for black women – notably through the sale of relaxers, hair colour, wigs and hairpieces. Using dyed strands of hair, the artist created a series of cyanotypes: simple and low-cost images reliant on the chemical reaction to sunlight of photosensitive solution on paper, resulting in a negative white image where the composition is shielded from light exposure and a vibrant blue ground where exposed. These pieces were sold on the market stall alongside other works by Gregory ranging in price from 50p to £500, depending on the blonde subject's degree of celebrity and public recognition.

The cyanotypes prove an effective medium for layered messages about beauty. The combination of blonde and blue calls to mind the feminine ideal of blonde hair and blue eyes, costly and potentially painful aspirations for those born without them. Methylene blue is a common chemical compound used as a rinse to perfect the platinum blonde effect after applying peroxide. Blue rinsing can also be related to the beauty industry's efforts to conceal female ageing, since it is also a process used by older women to reduce the yellowing of grey hair.

Conrad Botes [Konradski] (born 1969)

'The Passion of the Witrot' in *Bitterjusi*, October 2004, no. 21

Published by Orange Juice Design, Durban | 41.5 × 29.5 cm (closed) | V&A: National Art Library PP.25.D

In 1992, as students at Stellenbosch University, Conrad Botes and Anton Kannemeyer founded *Bitterkomix*, a satirical magazine in comic-book format that has since become notorious in South Africa. The early issues were written in Afrikaans, with abundant references to Afrikaner culture; the magazine has since has developed into a broader critique of South African society, post-apartheid. There have been two collaborative issues with *I-jusi*, a magazine produced by the Durban-based graphic design studio Orange Juice Design. Here, in 'The Passion of the Witrot', Botes employs some of his familiar characters – the tortured soul and the femme fatale – in a narrative of torment, temptation and martyrdom.

Ellen Gallagher (born 1965)

Detective Training, 2004

Laser-drawing with laser-cutting on Japanese paper; 58/100 | 12.7 × 10.2 cm | V&A: E.543–2005
Purchased through the Julie and Robert Breckman Print Fund

Ellen Gallagher works primarily in monochrome, sharing an oft-quoted affinity with the work of Agnes Martin, but her images are more complex than simply 'black and white'. Gallagher's exquisite graphic sensibility frequently explores racial stereotypes. She does so not by literally re-creating them but rather through mining the complex grey area of lived experience 'despite/around/within stereotype'.[1] Beginning with an interest in the ephemera of minstrel shows, with its racist visual shorthand of bug-eyes and thick lips, she decontextualizes these symbols to create what she refers to as a 'cosmology of signs': 'You start off with a limited class of signs and, like jazz, you revisit and repeat with slight changes and build structure […] I think that's where you can talk about race in terms of my work – you choose to engage with this cosmos which is very personal.'

Detective Training was created on the occasion of Gallagher's solo exhibition at the Fruitmarket Gallery in Edinburgh. Gallagher works on a variety of pictorial scales from monumental works on paper to the humble dimensions of 'anti-spectacularity' as in this print. 'Paper as support, its own materiality is usually ignored. So the sense of a neutral surface that can accommodate any mark seems an ideal way of communicating freedom.' The signs, repeated like jazz riffs in this small-scale print, include wigs, corsets, guns and their attendant bullet holes. Gallagher alternately applies her mark-making by adding, often in collage, or subtracting, here creating cutwork perforations in the paper by laser-cutting. The source material came from advertisements in black magazines from the 1970s for the company Medalo, suppliers of an incongruous selection of hairpieces, undergarments and firearms. Free-floating across the surface of the paper, the viewer is left to surmise how these objects interrelate and might prove useful for investigation or espionage, both of which were frequently plot lines in 1970s 'blaxploitation' cinema. The laser cuts provide a frame, which isolates the individual symbols: 'The frame is very important to me – it's one of my attractions to print making – you work against constriction.'

1. All extracts quoted in Jessica Morgan (ed.), *Ellen Gallagher* (Boston, MA., 2001).

Glenn Ligon (born 1960)

Stranger, 2006–7

From the Rivington Place portfolio
Printed by Randy Hemminghaus | Published by the Brodsky Center for Innovative Editions at Rutgers, the State University of New Jersey
Photogravure; 27/50 | 76 × 51 cm | V&A: E.163:6–2009
Purchased with the generous support of the Friends of the V&A

Glenn Ligon's *Stranger* comes from a series of paintings begun in 1996, in which he appropriates quotations from James Baldwin's essay 'Stranger in the Village'. Written in 1953, it details the writer's experience in the remote and then virtually unknown Swiss town of Leukerbad and his reception by the residents who had never before seen a 'Negro'. Their curiosity, scrutiny and intense examination results in the villagers overlooking Baldwin's fundamental humanity:

> All of the physical characteristics of the Negro which had caused me, in America, a very different and almost forgotten pain were nothing less than miraculous – or infernal – in the eyes of the village people. Some thought my hair was the color of tar, that it had the texture of wire, or the texture of cotton … If I sat in the sun for more than five minutes some daring creature was certain to come along and gingerly put his fingers on my hair, as though he were afraid of an electric shock, or put his hand on my hand, astonished that the color did not rub off. In all of this, in which it must be conceded there was the charm of genuine wonder and in which there were certainly no element of intentional unkindness, there was yet no suggestion that I was human: I was simply a living wonder.[1]

This image relies on nuances of language and its interpretation, so often evident in Ligon's work. It explores the interplay between denotation and connotation, here specifically of the word 'black'. Abstract Expressionist in appearance, it shows the cross-section of a paint sample under high magnification, referring to his own *Stranger* series of oil paintings. The accompanying text assesses the relative purity of black pigment contained in the sample, citing 'wood charcoal', and the pigments 'bone (or ivory) black' and 'lamp black' among the findings. It concludes that 'the problem with the sample is that there seemed to be no pure black' and posits 'that the artist thought pure black would give too dark an effect'.

Certainly, this analysis doubles as a mordant commentary on the impossibility of pure blackness and the inherent absurdity of pseudo-scientific racial constructs. Another key print of Ligon's is the 1998 silk-screen-on-canvas diptych *Self-Portrait Exaggerating My White Features/Self-Portrait Exaggerating My Black Features*, which, taken at face value, compels the viewer to interpret slight printing nuances in otherwise identical images as proof of differences where none exist in reality.

1. For full text of 'Stranger in the Village' essay, 1955 Beacon Press edition, see https://pantherfile.uwm.edu/gjay/www/Whiteness/stranger.htm; access date 9 August 2012.

160x

Plate 2. Glenn Ligon, Stranger. Photomicrograph of paint cross-section, photographed in reflected light under the microscope at 160x.

1. In none of the paint or ground samples were the characteristic splinter-like particles of wood charcoal seen. The pigment particles viewed under the optical microscope were small and rounded, or larger aggregates of such particles. Unfortunately it was in this case impossible to say whether the pigment was bone (or ivory) black or lamp black, since the particles of these two types of black look very similar not only under the optical microscope, but also in the SEM. A method which has been used by us successfully in the past is X-ray diffraction which gives for bone or ivory black a powder pattern for calcium phosphate. The problem with the sample is that there seemed to be no pure black paint; even an apparently intense black was found to contain scattered particles of lead white, earth pigments, and often vermillion, so that the sample would have given an impossibly confused powder pattern. At some future date it may be possible to identify the black in a sample by combined SEM/XRF analysis. It is conceivable that the artist thought pure black would give too dark an effect.

Carrie Mae Weems (born 1953)

When and Where I Enter, the British Museum, 2007

From the Rivington Place portfolio | Printed by Randy Hemminghaus
Published by the Brodsky Center for Innovative Editions at Rutgers, the State University of New Jersey
Digital print on paper; 27/50 | 76 × 51 cm | V&A: E.163:9–2009 | Purchased through the generous support of the Friends of the V&A

Carrie Mae Weems is best characterized as an artist who uses photography; her work invariably has an implicit socio-political message, often with herself as an actor in a narrative that draws on historical incident and links past and present, art and reality.

A scholarship to Rome in 2006 gave Weems the opportunity to travel to major European cities, seeking out symbolic architecture and recording her own presence in these places, both as an individual and as a signifier of the black presence in history and society. In an echo of her installation *Ritual & Revolution* (1998), where she pictured herself as everywoman, dressed in timeless draperies beside classical columns, Weems positions herself here as observer/outsider at the entrance to the British Museum. The dress and pose of the figure can be read as both contemporary and historic, and her position – standing apart from the crowd entering the building, her back turned to the viewer – implies some uncertainty or ambiguity: an isolated emphatic figure, suggestive of confrontation as well as contemplation, exclusion but also belonging. Seen from behind, her race is not immediately apparent. She has said, 'We can set that aside', explaining that she saw herself 'functioning as a guide in an architectural place that asks another set of questions about power and relationships that perhaps we can all then stand in front of.'[1]

1. Quoted in Hilarie M. Sheets, 'Photographer and Subject are One', *New York Times*, 12 September 2012.

THE WAYWARD THINKER TRENTON DOYLE HANCOCK 2007

Trenton Doyle Hancock (born 1974)

The Wayward Thinker, 2007

Colour screen print; 14/100 | 43.2 × 32 cm | V&A: E.1276–2011

'I was that geeky kid who sat in the back of the class and just drew pictures. I didn't ever want to be a fireman or a doctor or anything else. I just wanted to be an artist.'[1] On the occasion of Trenton Hancock's first solo exhibition in Europe at the Fruitmarket Gallery in Edinburgh, the artist produced this print fusing his complex cartoon style and idiosyncratic hand lettering. Hancock has invented a rich universe populated by allegorical archetypes, based on creation myths and Bible stories of his youth (he grew up with a Baptist minister stepfather) and merged with the popular culture of the late 1970s and 1980s.

With Philip Guston as a key influence, Hancock uses the formal structure of comics – a low-cost print medium incorporating text and image within a grid – in a variety of ways to establish the framework for his working practice. This spans painting, performance and illustration. Creating his own symbology, Hancock's often riotously colourful compositions pit ossified creatures known as Vegans (who experience the world solely in black and white) against the peace-loving Mounds, part-plant, part-animal (who think and dream in vivid colour). His work also shares an affinity with Laylah Ali's *Greenheads*, another fictive race that stands in for the artist and represents humanity more generally – at its best

and its worst. Hancock has described his interest in lettering as providing a 'new texture' for his images, often employing anagrams and the power of language to convey information in different registers.

Although this is a monochromatic print, the central hand in this image of disembodied members cradles three carefully balanced eggs, each bearing colour references in embryonic form – yellow, green and blue – and hinting at Hancock's frequently psychedelic palette. The hands themselves suggest a frenzied, anxious energy. Hancock has recounted the enduring memory of his favourite television series, *The Incredible Hulk*, the 1977 pilot for which opened with a black screen and white lettering: 'Within each of us oft times there dwells a mighty and raging fury.' Another important reference from his teenage years was the John Landis film *An American Werewolf in London* (1981), which became an obsession. One might interpret the hands and claws depicted here as suggestive of both the Hulk's destructive 'smash hands' and as a metamorphosis from man to beast.

1. 'Contemporary Perspectives: Trenton Doyle Hancock', Boston University, 26 February 2007, *Smithsonian Magazine*, October 2007.

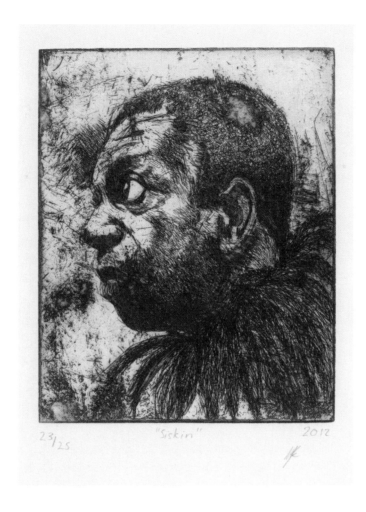

23/25 "Siskin" 2012

Lynette Yiadom-Boakye (born 1977)

Siskin, 2012

Etching; 23/25 | 37.8 × 28.5 cm | V&A: E.576–2012

'I've conceived Siskin as the first in a group or series. I've made four more but the public may not ever see them.'[1] This is painter Lynette Yiadom-Boakye's first fine art print. She brings to printmaking the same energy she devotes to her prolific painting technique, creating several plates at once just as she works on a number of canvas compositions concurrently before settling on which are to be fully realized and which will be destroyed or painted over.

With etching, I'm using line in a way I don't use in painting. Printmaking is more labour intensive as a practice. With print you're working in reverse, for one thing. It's hard to assess the look in the eye, the curve of the lip. If I get it wrong, I put the ground back and start over. Of the five I've just run off, one may be the wrong execution but his expression is just right – though it's too dark and the head's the wrong shape. Sometimes there's a tiny detail, an expression that's too passive. I realised it has to do with the lip and the eyebrow, the glint of light in the eye. I make several different plates at once, paying attention to different aspects; varying scale, details in dark, light, outline and tonality. I concentrate on different things with different plates. Then I run off five and can assess them aesthetically. With Siskin, it worked the first time.

For Yiadom-Boakye, each work exists as would a paragraph in a larger narrative. In this instance, *Siskin* continues on a more intimate scale the series of large paintings inspired by English birds, where figures are adorned with feathered collars but few other defining details. Influenced in part by Walter Sickert and his economical palette, her figures amalgamated from life, memory, books and magazines are individual yet somehow unwilling to reveal themselves fully, present and commanding yet just out of focus. While her subjects are most often black, the artist is matter-of-fact about how little bearing racial specificity has on her work: 'Blackness to me isn't odd or other. It just is.'

1. All quotations from interview with Zoe Whitley, 28 June 2012.

PROTEST

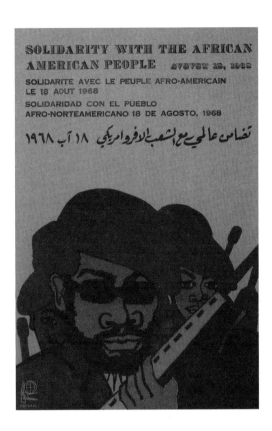

Emory Douglas (born 1943)

Solidarity with the African American People, 1968

Designed by Lazaro Abreu for OSPAAAL, Cuba | Colour offset lithograph | 54.2 × 35.7 cm | V&A: E.798–2004
Gift of the American Friends of the V&A; gift to the American Friends by Leslie, Judith and Gabri Schreyer and Alice Schreyer Batko

The graphics of Emory Douglas are today synonymous with the Black Panther Party for Self-Defense (BPP), founded by black nationalists Huey P. Newton and Bobby Seale in Oakland, California in 1966. Douglas, by that time, had completed his studies at City College and joined the Panthers, impressed by their discipline and organization, which he credits with transforming his thinking.

Frustrated at the crushing effects of poverty, social inequality and police brutality on inner-city black people, the Panthers instigated an aid programme whose idea, said Douglas, 'was to give away high quality stuff to the community. They deserve it.'[1] This spanned food, clothing, shoes and printed matter to educate and empower the community. Douglas employed his background in graphics and illustration to support the cause. He was designated the BPP Minister for Culture.

'Each one, teach one. There was always a cadre of folks who worked with you. They may have had art skills but didn't understand how to put the political content into art. So that became my responsibility.'[2] Central to Douglas's art was an empathetic depiction of disenfranchised black people, imbuing them with power and strength at a time when there were few positive black images in the popular imagination. True to the founding tenet of the party, which promoted self-defence, agency and empowerment for black people, Douglas's imagery often features armed figures, no

longer victimized by their circumstances. Another popular recurring characterization was the porcine police officer. The first pig drawing was created in the apartment of fellow Panther Eldridge Cleaver, as a visual play on the derogatory slang terminology for the police. The pig caricature had a profound psychological resonance in the community, transforming a deep-rooted source of fear and oppression into an easily identifiable form of mockery that provided uplift where people previously felt helpless.

Key to the circulation of these images was the central distribution headquarters in San Francisco of the Black Panther Party Press (1968–78), which included its own darkroom for BPP photography. Benny Harris established the printing operation, re-conditioning one 'Chief 20' printing press, while having used another for spare parts. Harris recalls: 'My printing skills gradually developed over time as the press was used to print flyers, posters, pamphlets … Emory Douglas also provided me with valuable artistic guidance and proper artistic layout etiquette.'[3]

1. Emory Douglas Studio Visit, by Babylon Falling: http://vimeo.com/4188506; access date 7–8 August 2012.
2. Ibid.
3. http://www.itsabouttimebpp.com/Our_Stories/Chapter5/pdf/ BPP_ Print_Shop_History.pdf; access date 30 August 2010.

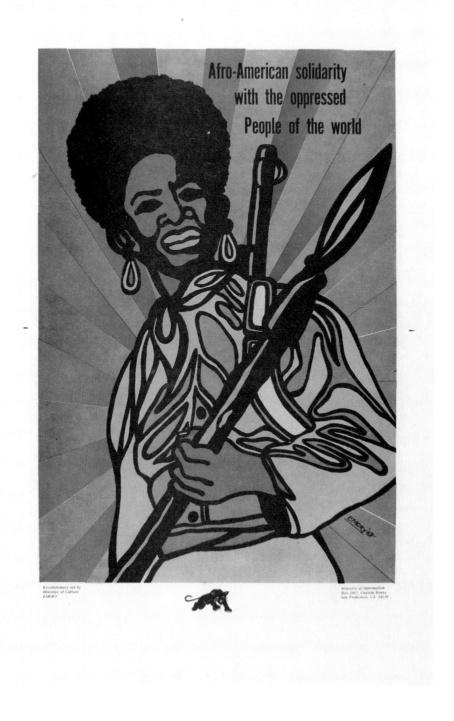

Afro-American solidarity with the oppressed People of the world, 1969

Colour offset lithograph | 57.8 × 37.5 cm | V&A: E.756–2004
Gift of the American Friends of the V&A; gift to the American Friends by Leslie, Judith and Gabri Schreyer and Alice Schreyer Batko

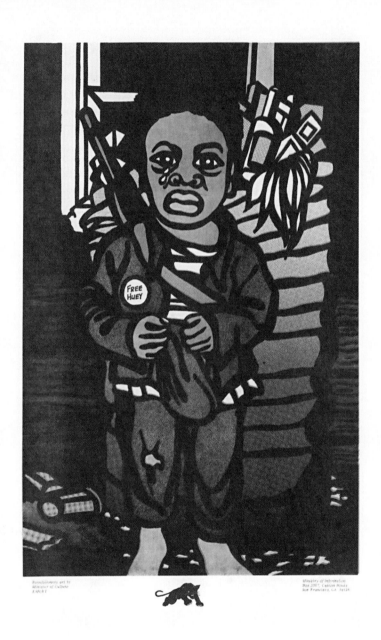

Free Huey, 1970

Colour offset lithograph | 57 × 38.1 cm | V&A: E.300–2004
Gift of the American Friends of the V&A; gift to the American Friends by Leslie, Judith and Gabri Schreyer and Alice Schreyer Batko

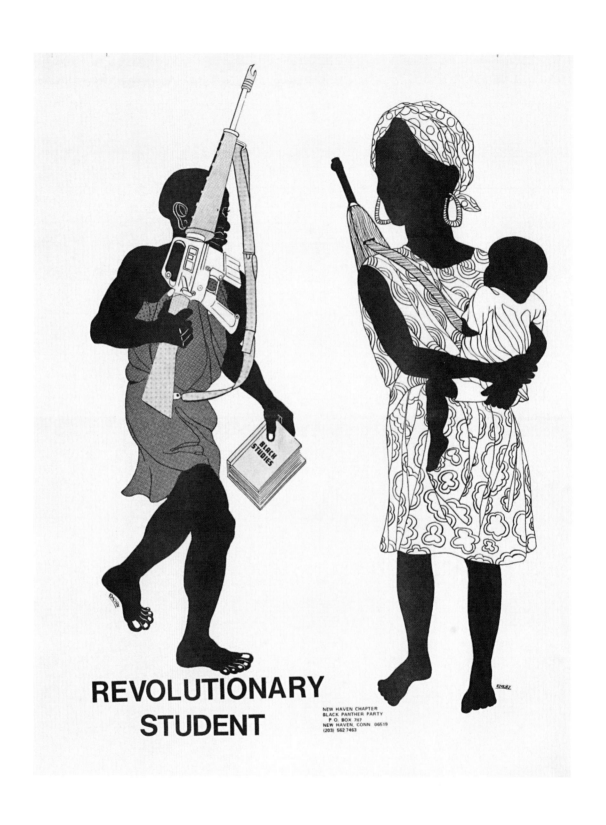

Revolutionary Student, 1970

Offset lithograph | 58.4 × 44.4 cm | V&A: E.303–2004
Gift of the American Friends of the V&A; gift to the American Friends by Leslie, Judith and Gabri Schreyer and Alice Schreyer Batko

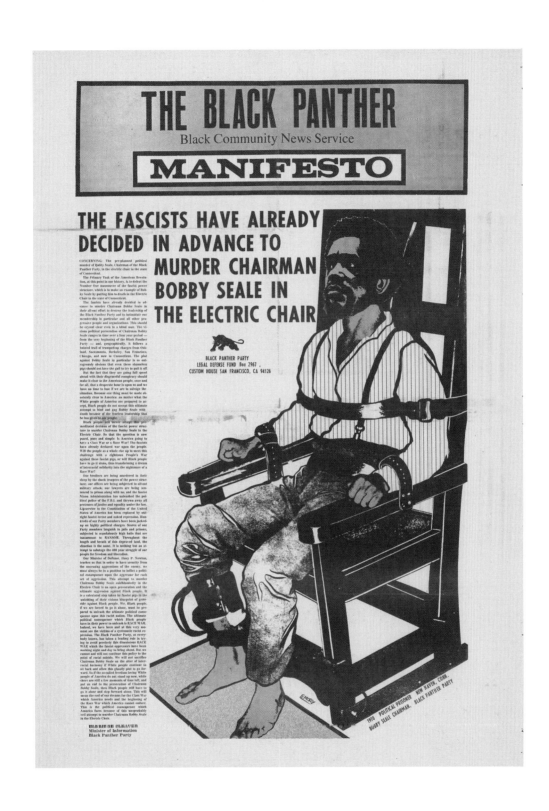

The Black Panther Manifesto, 1970

Offset lithograph │ 81.2 × 58.4 cm │ V&A: E.211–2004
Gift of the American Friends of the V&A; gift to the American Friends by Leslie, Judith and Gabri Schreyer and Alice Schreyer Batko

Llewellyn Xavier (born 1945)

From the *George Jackson* series, 1971

Screen prints (5); from edition of 75 (various) | Each 78.7 × 58.4 cm | V&A: E.3016-3020–2007 | Given by the artist

Llewellyn Xavier, born in St Lucia, was one of a number of black artists in Britain who, in the 1970s, produced work that engaged directly with political issues, especially discrimination and police brutality against black immigrants. He made lithographs, screen prints and mail art, using imagery drawn from photographs and news media to explore controversial real-life cases.

Most famously he made a series of 11 screen prints about the life and death of George Jackson, an African-American inmate of California's notorious Soledad Prison. Jackson's imprisonment became something of an international cause célèbre (see fig.8, p.18), which was to inspire powerful responses from artists and musicians as well as politicians and activists. Xavier was profoundly moved by reading Jackson's prison letters, published as *Soledad Brother* in 1970, and decided to make a series of works 'symbolizing his struggle'.[1] Jackson (1941–1970) had been imprisoned at the age of 16, having been accused of stealing $71 from a gas station, and was given an indeterminate sentence of one year to life. His sentence was reviewed annually but in fact he was never released. Jackson was politicized by his experience of discrimination and became an activist leader of the Black and Chicano prisoners in Soledad, and a member of the Black Panthers. In January 1970 Jackson was one of three men accused of murdering a white guard (in response to the killing of three black Muslim prisoners). In August, after being transferred to San Quentin and three days before he was due to stand trial, Jackson was killed by prison guards. The official report into the incident accused him of participating in a prison revolt earlier the same day but there were conflicting accounts of the incident and other reports say that he was killed attempting to escape.

Xavier's prints, made the following year, are a commemoration of Jackson, and a savage indictment of the system that made him a martyr and a hero for the Black Power movement. The prints were the outcome of what Xavier described as 'a contributory art'.[2] Employing photomontage to combine news cuttings and photographs with hand-drawn additions to create the initial images, Xavier then sent the works to well-known militants – including Jean Genet, Peter Hain (a vocal opponent of apartheid in his native South Africa, and later a British MP), James Baldwin and John Lennon – for comment. As Xavier recalled, 'on the way to their destination the embryo works (wrapped on the outside of the tubes) received "contributions" in the form of postage stamps, postal markings, and censorship stamps.'[3] He then translated these images, with their accumulated marks of passage, into a succession of screen prints. Exhibited in *Back to Black* at the Whitechapel Art Gallery, London, in 2005, these prints were described by reviewer Ruaridh McLean as embodying 'an act of brilliant polemic and challenging aestheticism'.[4]

1. *Llewellyn Xavier: exhibition on George Jackson*, exh. cat., DM Gallery, London, 13 October–2 November 1971, n.p.
2. Ibid.
3. Quoted in *George Jackson*, exh. cat., Whitechapel Art Gallery, London, 5–23 December 1972.
4. Ruaridh McLean, *Socialist Review*, July 2005; http://www.socialistreview.org.uk/article.php?articlenumber=9472; access date September 2012.

Gavin P. Jantjes (born 1948)

Freedom Hunters, 1977

Screen print with collage; 8/35 | 70.8 × 100.2 cm | V&A: E.333–1982

As a native South African, Gavin Jantjes has always been conscious of a responsibility to make 'art for liberation's sake'.[1] A scholarship to study in Hamburg, where he was taught by Joe Tilson, was followed by years of exile from South Africa in London, thereby providing an escape route from life under apartheid. Yet his work has often been profoundly political, distilling his anger at the injustices and cruelties perpetrated by the system. In prints such as the suite titled *A South African Colouring Book* (1974–5) he addressed the specifics of prejudice and discrimination predicated on precise calibrations of racial identity (Jantjes himself was categorized as 'Cape Coloured'). *Freedom Hunters*, one of his most overtly political prints, commemorates the infamous massacre of protesting black students in Soweto on 16 June 1976. The title is taken from a poem by Steven Smith (embedded in the print), which expresses the growing spirit of angry defiance, and concludes: 'We'll come down upon you as an epidemic of black freedom hunters.' Using techniques pioneered by print studios such as Kelpra in Britain, Jantjes spliced together text with photographic imagery, lifted from news media, to produce a viscerally direct account of an event which galvanized the fight for liberation in South Africa.

1. *Gavin Jantjes: Graphic Work 1974/78*, exh. cat., Kulturhuset, Stockholm, 1978, p.7. See also introduction to the current work, note 4, p.9.

Nils Burwitz (born 1940)

Namibia: Heads or Tails?, 1979

Colour screen print; 17/40 | 53 × 52 cm | V&A: E.899–1979

This print is another of Nils Burwitz's graphic responses to apartheid in South Africa (see also pp.31 and 46), which draws its power from replicating and recontextualizing the signs that policed the racial divisions in society in every respect, in life and death, labour and leisure. This is perhaps his most famous image – made in fact after he had left South Africa for Mallorca. A double-sided print, it reproduces both sides of a sign: one side warns the spectator that he is about to enter a prohibited area (the Diamond Zone in Namibia); the other is blank; both are riddled with bullet holes. Burwitz simulated the peeling layers of enamel surrounding the bullet holes in the original sign by repeated applications of thickened inks forced through the silk screens.

17/40

Sue Williamson (born 1941)

A Few South Africans: Amina Cachalia, 1984

Collage of colour screen print and photo-etching; 27/35 | 100.2 × 70.2 cm | V&A: E.83–2013 | Given by the artist

Made at a time when South Africa was still firmly in the grip of apartheid, the series *A Few South Africans* was an attempt to make visible the history of certain women who had made an impact in some way on the fight for majority rights. The 'few' of the title are representative of the largely anonymous many who were part of the struggle. Sue Williamson worked on the series over a period of years (1983–7) and completed 17 prints. Though some of their subjects – such as Winnie Mandela, Miriam Makeba and Helen Joseph – are now renowned, little was known about them at that time and their images never appeared in the popular press. In order to make their portraits the artist had to photograph them herself, or source images in banned books that she unearthed in university libraries and other archives. Through her mode of presentation she gave each of these women the status of heroine. The backgrounds reflected aspects of their personal histories, as did the patterns and motifs in the framing devices, which, as Williamson has explained, refer to the way in which people in the squatter towns and townships would use scraps of wallpaper, printed packaging and coloured gift wraps to elevate snapshots to the status of works of art. The central image of each is a photo-etching, sometimes with the addition of aquatint or hard-ground etching; the frames were screen-printed and collaged over the etched images. Motifs in the frames derive from African textiles such as kanga cloths (as worn here by Virginia Mngoma), or personal artefacts.

Referring to this series, Williamson has said, 'I like to make work people feel ready to get engaged with, so they don't just walk past. Lots of images are quite familiar images, so I re-present them so viewers are seeing something quite familiar to them in a new or different context. In many ways, I am acting as an archivist.'[1] The subjects of these prints have been documented by Williamson, with an account of each woman's life and her political role detailed in a catalogue that accompanied the publication of the series. Virginia Thoko Mngoma led protests against the hated 'pass laws' that required black South Africans to have permits, or passes, to work or travel; the most successful protest action she helped to organize was the Alexandria bus boycott in 1957 in response to a significant rise in fares. Amina Cachalia was born into one political family, and married into another, both active in India and in South Africa; as a leader of the Federation of South African Women, she protested on behalf of those banished to remote impoverished 'homelands', visiting them to offer food and assistance. The unnamed woman pictured in *Case No. (Anonymous)* represented the many who defied the laws that demanded that they live apart from their husbands in rural isolation, preferring to live illegally and precariously in the towns where their menfolk had employment.

An important part of the history of this series of prints is that they were also reproduced as postcards, in order to make the images widely accessible to the general public. These postcards have been described as 'one of the most important icons of the eighties'. This is reflected in Williamson's comment, 'My work is about people, rather than about myself. It's about stories of people in the community. At the same time, I feel allowed to use these stories to make my work so I like to put something back in again … I try to make things that are popular and will be understood by most people who look at it. I don't just want to talk to other artists, many of whom make work for their peers.'

1. All quotes taken from *Artthrob* (November 2003), no.75. See http://www.artthrob.co.za/03nov/artbio.html; access date August 2012.

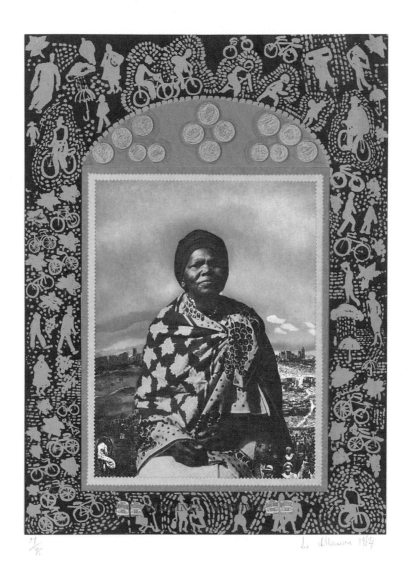

A Few South Africans: Virginia Mngoma, 1984

Collage of colour screen print and photo-etching; 27/35 | 100.2 × 70.2 cm | V&A: E.84–2013

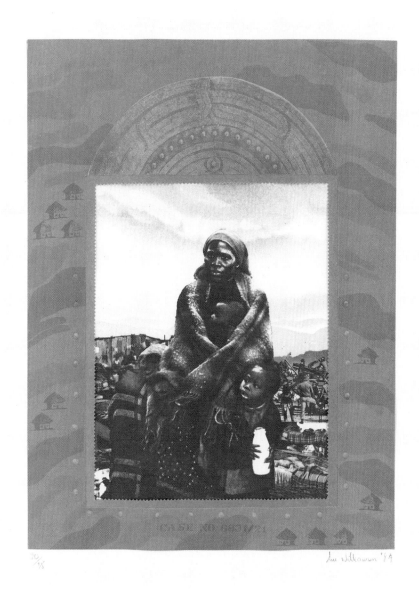

A Few South Africans: Case No. (Anonymous), 1984

Collage of colour screen print and photo-etching; 20/35 | 100.2 × 70.2 cm | V&A: E.85–2013

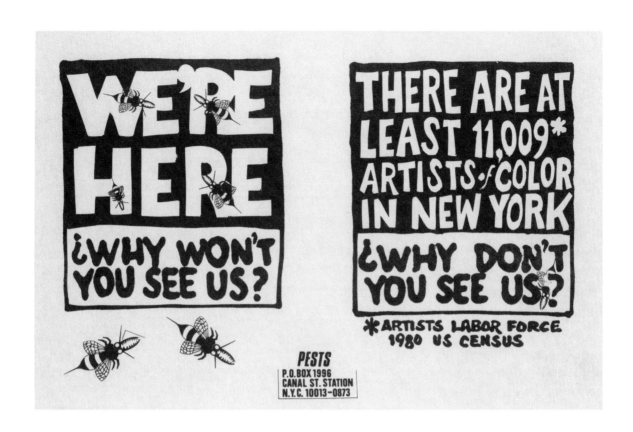

PESTs (anonymous collective)

Printed ephemera, 1986–9

Offset lithographs (6) | Dimensions various: from 3.2 × 20 cm to 21.5 × 41.5 cm | V&A: E.1189-1194–2012 | Given anonymously

This collection of printed ephemera was donated under condition of anonymity by a former member of PESTs, an important but relatively little-documented artists' group dedicated to improving visibility for non-white artists in the art world. PESTs (active 1986–9) was modelled on the success of the Guerrilla Girls, an anonymous group of feminist artists established in 1985, who highlighted the lack of diversity in the arts, particularly in representing female artists. Their primary tactic was a series of audacious awareness campaigns, beginning with wheat-pasted posters citing shameful representation statistics, which were located near offending art galleries and museums in Manhattan (at the time, practically all of them). The Guerrilla Girls' first poster to specifically address race – *No Gallery Shows Black Women* – appeared in 1986. Operating under pseudonyms of various female artists and writers from the distant and recent past, a Guerrilla Girl identified as 'Frida Kahlo' recounts: 'One of our members started PESTs. She did that simultaneously and got more involved in it and left Guerrilla Girls to do her own thing with PESTs. I remember her asking me for advice about some of the projects they did.'[1]

The activities, ranging from fly-posting, newsletter circulation and independent exhibitions, combined performance and protest to bring about more equality in gallery representation, museum acquisitions and exhibitions. PESTs sought to 'bug' the art world by means of pestering, infiltrating and surveillance in order to bring about positive change.

Some insight into PESTs dissemination of posters and stickers may be gleaned from the Guerrilla Girls, who described their posting technique as follows: 'We put them up at night. We decided to go out at midnight on Friday nights, because many of us lived in SoHo, and we knew that people would go out to the galleries in the morning. So if we went out late at night, we'd be finished about 3:00 a.m., and posters would be on the walls when the galleries opened.'[2] Possibly founded by the Guerrilla Girl known as Zora Neale Hurston, PESTs was instrumental in helping to 'change the face and complexion of American art,'[3] whether or not we can acknowledge its members by name.

1. Oral history interview with Guerrilla Girls [using pseudonyms] 'Frida Kahlo' and 'Kathe Kollwitz', 19 January–9 March 2008, Archives of American Art, Smithsonian Institution; http://www.aaa.si.edu/collections/interviews/oral-history-interview-guerrilla-girls-frida-kahlo-and-kathe-kollwitz-15837; access date 19 July 2012.
2. Ibid.
3. Whitney Chadwick, *Confessions of the Guerrilla Girls* (London, 1995).

HOW OFTEN DO YOU SEE A ONE PERSON SHOW BY AN ARTIST OF COLOR?

PESTS STRIP

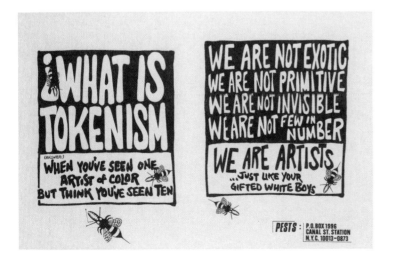

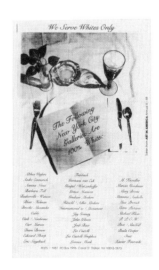

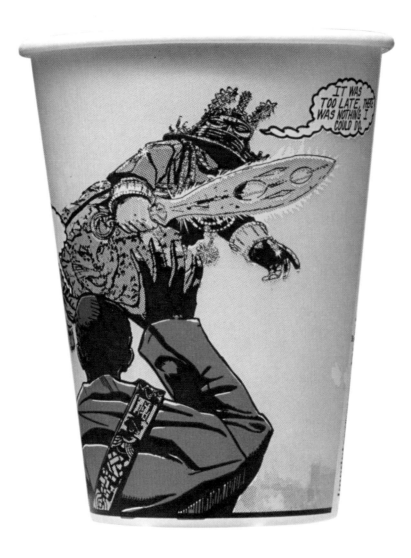

Kerry James Marshall (born 1955)

Paper cup produced for *Imprint: a public art project*, 2002

Half-tone | V&A: E.371–2005 | 11.3 × 9 cm | Given by Rosie Miles

This is one of a set of six paper cups designed for *Imprint*, a public art project organized by The Print Center, Philadelphia, in 2002. Artists were invited to produce printed matter for a range of urban situations including billboards, bus shelters and magazine inserts as well as the cups used in selected cafés in the city during the project. Kerry Marshall chose to adapt imagery and a storyline from his ongoing comic-strip series, *Rythm Mastr*, begun in 1999. His protagonist is a typical comic-book hero, fighting against injustice; he is imagined as an African spiritual leader whose drumming can summon powerful superheroes (akin to African Orishas, or spiritual intercessors). Marshall's storyline addresses aspects of African-American experience, which he has described as 'an epic story of vengeance and redemption, set against the backdrop of gang violence, and urban renewal, on the south side of Chicago.'[1] His focus is the plan to demolish Chicago's high-rise public housing projects and the unresolved fate of the people displaced: 'Where will they go?' asks Rythm Mastr, and the hovering Benin-helmeted figure adorned with Asante gold disks, responds: 'It was too late. There was nothing I could do.'

1. Kerry James Marshall, Artist's Statement for IMPRINT, quoted in *Imprint: a public art project*, The Print Center, Philadelphia (2002), p.15.

Yinka Shonibare MBE (born 1962)

Climate Shit Drawing 1, 2008

Colour lithographs (4) with silk-screen glaze, collage with fabric and foils; 99/200 | 50.4 × 34.4 cm | V&A: E.161–2009

Climate Shit Drawing 1 is Yinka Shonibare's first fine art print, which also marked the artist's first series of works on paper and coincided with an international tour of his mid-career retrospective. He masterfully uses pattern to make political statements both subtle and overt. He made his name with visually arresting installations in boldly coloured wax print textiles, material that ostensibly asserts itself as authentically 'African', though its origins can be traced to the Dutch trade in Indonesian batiks, disrupting any preconception of a single pure or authentic cultural tradition.

Relocated to the setting of museums and art galleries, Shonibare's montages and *mise en scènes* reference works from the history of European art – by Boucher, Fragonard, Watteau, Hogarth and others – in order to interrogate ideas of race, class and subjectivity in the global circulation of wealth and cultural capital. These concerns also manifest themselves in the pressing issues of financial inequality, climate change and unequal access to information.

Here the beguiling floral pattern is more than it first appears. Using the sensual line of automatic drawing, he combines the inherently attractive batik patterns and gold leaf with collaged images of faecal matter – the 'shit' of the title. Newspaper clippings are also introduced, many of which are extracted from the *Financial Times*, operating as a reference to the global financial crisis caused by corporate greed but equally employed for its own distinctive patterning created by its signature pink paper.

GLOSSARY

Below is a summary of the printmaking terms most pertinent to this book. For more detail on these and other terms see Susan Lambert, *Prints: Art and Techniques* (London, 2001), which describes all the more traditional processes. Bamber Gascoigne's *How to Identify Prints* (London, 1986) is a comprehensive guide to manual and mechanical processes. The processes of digital technology are immensely complex but have been described on various websites, such as http://en.wikipedia.org/wiki/Category:technology

Cyanotype
A photographic process (also known as Blueprint process) that produces a white line on a blue ground, using paper that has been sensitized to light by being impregnated with iron salts (this gives the blue coloration to the finished print). Areas of the paper are blocked out using negatives or stencils; the paper is then exposed to UV light (often sunlight) for a few minutes. After exposure the paper is washed with water. The area that has been blocked out remains white, while the area that has been exposed turns blue.

Digital print
A print whose image has been created with the aid of a computer program in which visual information has been stored and can be retrieved and transmitted according to a numerical system. Using this system the image has been broken down into dots of colour or 'pixels', which occur at a specified number per square inch. The higher the number per square inch, the higher the 'resolution' or ultimate sharpness of the image.

Drypoint
A type of engraving in which the design is gouged directly into the metal printing plate using a sharp metal point. The process throws up tiny pieces of metal that lie on the surface to either side of the incised line; this residue is known as the 'burr'. It is not removed from the plate before printing. When the plate is inked, extra ink is held by the burr, resulting in a soft velvety line. The burr is gradually eroded by repeated printing, so early impressions from a drypoint plate are regarded as being of higher quality than later impressions.

Edition
The artificially limited number of impressions printed from a plate or, in the case of more recent printmaking processes, reproduced from any other photo-mechanical or digital-processing technology.

Etching
An intaglio process in which a drawing is made with a specially designed etching needle into a waxy resin or 'ground' covering a metal plate. When the drawing is complete, the whole is placed in an acid bath, so the metal exposed by the needle is etched (or 'bitten') into by the acid. The plate is then washed, inked and printed. The depth of etch depends on the length of time the plate is immersed in the acid. Variations in the process include:

Soft-ground etching, in which the conventional etching ground is mixed with tallow. The etcher draws the design on thin paper laid on top of the ground; when lifted away the paper takes with it the ground in those areas where it has been impressed with the drawing implement. Soft-ground etching is often used to produce lines that look like chalk or pencil drawing.

Aquatint, in which the ground is applied in the form of powdered resin, which is adhered to the plate by heat. The acid bites around each particle of resin resulting in a grainy, tonal effect in the print.

Brush bite, created by painting acid directly on to an un-grounded plate with a brush. It is characterized in the print by a build-up of ink at the edges of the brushed areas.

Spitbite aquatint, which involves painting strong acid directly on to the aquatint ground of a prepared plate. Depending upon the time the acid is left on the plate, a range of light to dark tones can be achieved. The application of the acid can be controlled by the use of saliva, or certain chemical solutions. Traditionally, a clean brush was coated with saliva, dipped into nitric acid and brushed on to the ground, hence the term 'spitbite'.

Photo-etching (see *Photogravure*)

Halftone
Any process – intaglio, relief or planographic – where the original image has been photographed through a cross-line screen to break up areas of solid tone into a mass of dots, enabling the enlargement or reduction of images without loss of clarity. If a fine screen is used the dots are seen as a continuous tone (though the dots will be visible through a magnifying glass), but with a coarser screen (as used for newsprint, for example) the process is more obvious.

Inkjet print
A print produced from a printer in which the ink is transferred to the paper (or other substrate) from a mechanism comprised of a number of tiny nozzles. Under high pressure, each nozzle sprays ink on to the paper.

Intaglio

A process in which the ink is pressed into cut-away/acid-eaten areas of the plate and the surface wiped clean. Plate and dampened paper are put through the press together, so the ink is forced out of the incised/bitten areas and on to the paper.

Iris print

A print from an Iris inkjet printer, developed by Scitex in the 1980s for proofing offset lithography but refined for fine art usage in the 1990s. Originally it used dye-based inks where many other inkjet printers used pigment-based inks.

Laser drawing/cutting

A laser directed by a computer program burns a line on to the paper, or cuts through the paper, to create cut-out areas.

Letterpress

A relief printing process developed for the printing of type, in which the print is usually made by the pressure of a large flat plate on to paper overlaying inked metal or wooden type.

Linocut

A process similar to woodcut but using a piece of linoleum instead of a wood plank. Linoleum has no grain and is soft and easy to work, but because it tends to crumble it is impossible to achieve fine lines with this medium.

Lithograph

A planographic process in which a design is drawn/painted using a greasy ink or 'tusche' on a printing plate (originally stone but now more commonly a zinc plate). The plate is then washed with a mixture of gum arabic and weak acid to make the blank areas receptive to water. It is washed again with water, which rolls off the greasy drawing but adheres to the blank surfaces. The plate is then inked up, but the ink only adheres to the greasy drawing, not the watery blank surfaces. Plate and paper are then put through the press. The process can be repeated with different 'drawings' for different colours in the image.

Monotype

A means of producing a single unique impression. The artist draws the design in printing ink on to a metal plate or sheet of glass, and this is then transferred to a sheet of paper by passing both through a printing press while the ink is still wet.

Offset

Any process (especially lithography) in which the image is taken up on to an intermediate cylinder and transferred from there on to the final substrate. The ink can be more reliably controlled than in the direct printing method. The resulting image may be 'flatter' than a non-offset print, but usually it is impossible to tell the difference, especially with the naked eye. Nowadays, however, virtually all commercial applications – and others where photographic processes are used to create the original image on the plate – are offset.

Photogravure

An intaglio process made with the intervention of photography. The abbreviated term 'Gravure' is commonly used with reference to mechanical production, in which a halftone screen is used to achieve tonal variations.

Planographic process

One in which the ink is applied to a printing plate that has not been incised or cut away, so the ink lies on the flat surface, with the un-inked areas achieved through a chemical repelling of water by grease (as in lithography) or through the presence of a partially masked screen or stencil (as in screen print).

Relief print

Any process, such as **linocut**, **woodcut** or **letterpress**, where the cut-away areas of the printing block do not receive the ink while the areas remaining and standing proud are inked with a roller. It is from these inked areas that the impression is taken.

Screen print (also known as **silk screen** or **serigraphy**)

A planographic process in which the 'plate' is a fabric screen, stretched taut, on to which a design has been applied. This can either be done by adhering a stencil to the screen or by covering the screen with a resist, drawing into this with greasy crayon and then treating the screen so that the drawing is washed away and the rest of the screen blocked out. Stencils can also be made using photographic processes and light sensitive gelatine to block the mesh. To print, ink is forced through the mesh of the screen (where the stencil is not blocking it) with a rubber blade on to the substrate. The screen-print process can be used to print on to a variety of surfaces, not necessarily flat, including fabric and ceramic. The screen is usually of silk – hence the American preference for the terms 'silk screen' or 'serigraphy' – but may also be made of nylon, cotton, or even metal.

Woodcut

A process by which parts of a wood block are cut away, parallel to the grain, leaving raised areas to carry the ink.

ACKNOWLEDGEMENTS

The authors would like to thank the many people who have contributed to the production of this book and have supported the research and writing. In particular, we would like to acknowledge the various contributions of V&A colleagues past and present, especially Rosie Miles, Margaret Timmers and Susan Lambert for their prescience and discernment in acquiring for the V&A many of the works featured here, and for their efforts in documenting them. We have inevitably drawn heavily on their work, and that of Helen Mears, whose research project (supported by a grant from the Heritage Lottery Fund) documented material from Africa and the diaspora in the V&A collections. Many of the artists have also been generous with their time in both conversation and correspondence, as has Deputy Director Jon Wilson at the National Great Blacks in Wax Museum in Baltimore, Maryland. We are especially grateful to Rosie and Margaret for reading our first draft; they both offered invaluable advice and much additional information as well as incisive editorial comments.

We must also thank Denny Hemming for her thorough and sensitive copy-editing of the text throughout. Any errors of fact or infelicities of expression that survive are our own. Many thanks are also due to our original V&A editor, Kaitlyn Whitley, for her guidance in the first phase of the project, and to Tom Windross, who stepped so ably into the breach when Kaitlyn left the Museum and saw the book through to publication. We also wish to recognize the enthusiasm and vision of the late Ewan Robertson of Oscar & Ewan, who embraced this project with characteristic originality in his design approach. All credit is due to Oscar Bauer for realising the final layout.

All the works included here are in the V&A collections, and many have come to the V&A thanks to the generosity of individual donors; they are duly credited in the text.

Gill Saunders and Zoe Whitley

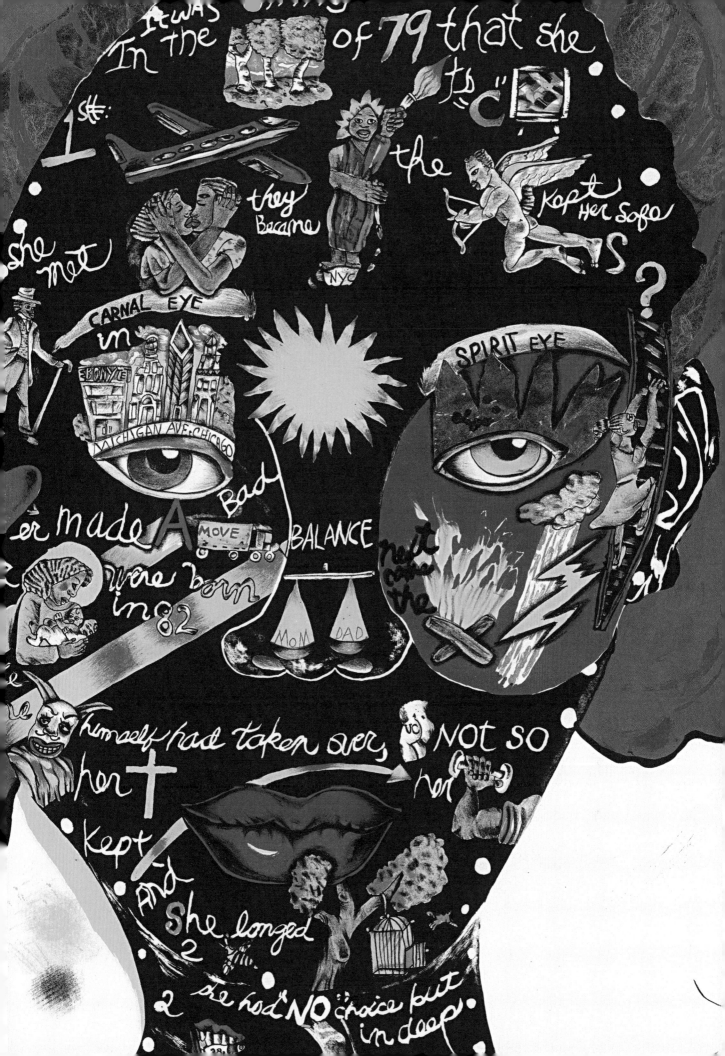

INDEX OF ARTISTS AND WORKS

PICTURE CREDITS